POSTCARD HISTORY SERIES

Western Kentucky

IN VINTAGE POSTCARDS

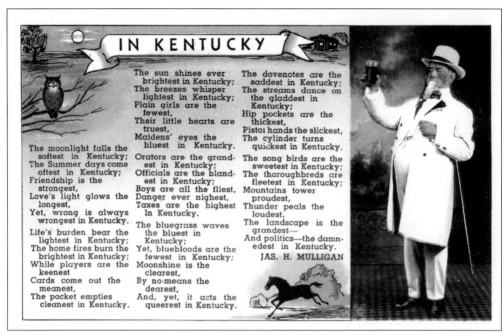

IN KENTUCKY

The moonlight falls the softest in Kentucky;
The Summer days come oftest in Kentucky;
Friendship is the strongest,
Love's light glows the longest,
Yet, wrong is always wrongest in Kentucky.

Life's burden bear the lightest in Kentucky;
The home fires burn the brightest in Kentucky;
While players are the keenest
Cards come out the meanest,
The pocket empties cleanest in Kentucky.

The sun shines ever brightest in Kentucky;
The breezes whisper lightest in Kentucky;
Plain girls are the fewest,
Their little hearts are truest,
Maidens' eyes the bluest in Kentucky.

Orators are the grandest in Kentucky;
Officials are the blandest in Kentucky;
Boys are all the fliest,
Danger ever nighest,
Taxes are the highest In Kentucky.

The bluegrass waves the bluest in Kentucky;
Yet, bluebloods are the fewest in Kentucky;
Moonshine is the clearest,
By no-means the dearest,
And, yet, it acts the queerest in Kentucky.

The dovenotes are the saddest in Kentucky;
The streams dance on the gladdest in Kentucky;
Hip pockets are the thickest,
Pistol hands the slickest,
The cylinder turns quickest in Kentucky.

The song birds are the sweetest in Kentucky;
The thoroughbreds are fleetest in Kentucky;
Mountains tower proudest,
Thunder peals the loudest,
The landscape is the grandest—
And politics—the damnedest in Kentucky.

JAS. H. MULLIGAN

"IN KENTUCKY" POEM. Over the years numerous songs and poems have been written about Kentucky. The last phrase of this poem alludes to politics in Kentucky; the campaign slogan "vote early and vote often" is still heard in some counties.

POSTCARD HISTORY SERIES

Western Kentucky

IN VINTAGE POSTCARDS

Clifford J. Downey

ARCADIA

Published by Arcadia Publishing,
an imprint of Tempus Publishing, Inc.
2 Cumberland Street
Charleston, SC 29401

Printed in Great Britain.

Library of Congress Catalog Card Number: 2002107409

For all general information contact Arcadia Publishing at:
Telephone 843-853-2070
Fax 843-853-0044
E-Mail sales@arcadiapublishing.com

For customer service and orders:
Toll-Free 1-888-313-2665

Visit us on the internet at http://www.arcadiapublishing.com

Dedicated to my daughter, Rebecca Leigh Downey, who accompanied the author on several visits to antique stores throughout Western Kentucky. During most trips Rebecca patiently stood by while her Daddy searched through stacks of dusty postcards. She even uncovered a couple of cards herself, which are included in this book.

CONTENTS

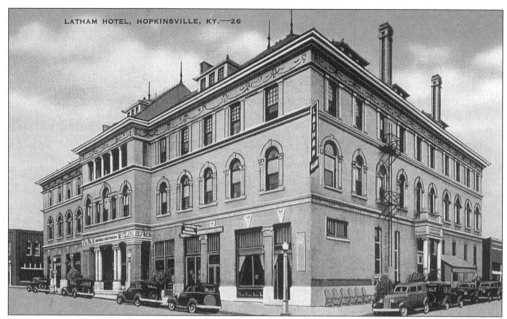

LATHAM HOTEL, HOPKINSVILLE. Over the years several fine hotels have been built in western Kentucky. One of these is the Latham Hotel in Hopkinsville. This card shows the hotel in the late 1930s, shortly before it was destroyed by fire. More information about this hotel and a view from the early 1900s can be seen on page 15.

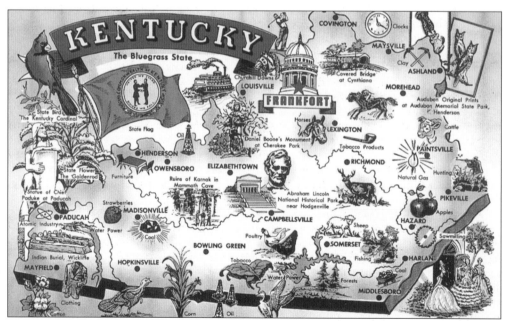

GREETINGS FROM KENTUCKY. As this card illustrates, a wide variety of crops and manufactured goods are produced in the Bluegrass State. This book takes a postcard tour through the western region of the state, from Hopkinsville north through Madisonville to Henderson and then westward to the Mississippi River. This map illustrates the cities of western Kentucky in relation to other cities in Kentucky.

INTRODUCTION

In this book, we will take a postcard odyssey through many of the towns and cities of western Kentucky. The cards date from the early 1900s to the mid-1960s, but regardless of their age, all serve as neat reminders of life as it once existed in the area. Thanks to these cards we can step back to 1907 and look inside a bank in the small town of Pembroke to see the elegant woodwork and brass spittoons, or visit Mayfield on Mule Day, when farmers from the surrounding towns gathered to buy and sell the mules used to pull plows and wagons.

Before proceeding, it would be useful to map out the territory covered in this book because some folks in Kentucky seem to disagree where "western Kentucky" is. Many residents in the eastern and central regions of the state seem to believe that western Kentucky includes all of the land west of Louisville, the state's largest city. But if this definition were accepted, then it would mean that "western Kentucky" covers nearly half of the state.

For the purposes of this book, "western Kentucky" is defined as the area from Hopkinsville north through Madisonville, onward to Henderson along the Ohio River, and then westward to the Mississippi River. It is bordered on the south by the Kentucky-Tennessee border and on the north by the Ohio River. The area is largely rural and most towns in the region never have had a population of more than 5,000 residents. In most counties, farming has been the dominant industry for decades, and several postcards illustrate the wide variety of crops and livestock raised in the area.

Despite the region's rural nature, western Kentucky has also boasted several large factories, including the Mayfield Woolen Mills and the Illinois Central Railroad locomotive repair shops at Paducah. Unfortunately, manufacturing in the region has taken a major hit as companies moved factories to other countries. Coal mining has also been a dominant industry, but within the past two decades, most mines have closed as power plants forsake west Kentucky coal (which is high in sulfur), and began burning low sulfur coal from Wyoming. Several postcards of the various mines and factories of the region are included as reminders of this bygone era in industrial production.

Coinciding with a decline in mining and manufacturing has been a dramatic growth in the tourism industry. Most of the tourism is centered on Kentucky Lake and Barkley Lake, two massive manmade lakes east of Paducah. Kentucky Lake was created by damming the Tennessee River and Barkley Lake was created by damming the Cumberland River. These two dams were completed in 1944 and 1965, respectively. Since the 1940s, the lakes and dams have been the subject of hundreds of postcards.

Kentucky Lake and Barkley Lake run parallel to each other, and the 10- to 15-mile-wide strip of land between the two lakes is known as "Land between the Lakes" (LBL). When LBL was created in the 1960s, the United States government bought all homes, farms, businesses, and land in this area, relocated all of the residents, and then destroyed all buildings and turned the land into a recreation area. Not surprisingly, this move created a lot of controversy and bitterness, especially since some of the families had been relocated during the early 1940s from the land flooded by Kentucky Lake.

The postcards are sorted geographically and arranged much like a driving tour. Our postcard odyssey begins in Hopkinsville, known locally as "Hoptown." We then venture north through Madisonville to Henderson, turn southwest and travel through Princeton, Marion, and Dawson Springs. We will look at the lakes region before proceeding on to Murray and Mayfield, stop at Paducah for a while, and then explore the river towns in far western Kentucky.

Near the beginning of the tour, we will take a brief detour through Central City and the now extinct town of Paradise before moving onto Greenville and Guthrie. Towards the end of our postcard voyage, we will hop across the Ohio River and take a quick visit to Cairo, Illinois, which is located at the junction of the mighty Ohio and Mississippi Rivers. Although the town's glory days are long gone, Cairo was once an important marketplace for folks in western Kentucky. Central City, Paradise, Greenville, Guthrie, and Cairo are actually just outside the western Kentucky region as defined above, but are included because they are of special interest to the author.

While putting together this book, the author did his best to locate postcards from smaller towns so they may be equally represented along with the bigger cities. Additionally, preference was given to postcards depicting buildings that are no longer standing, such as the elegant hotels at Dawson Springs, whose famous spring water was believed to cure a variety of ailments. By presenting these postcards, the author hopes to stir some fond memories of bygone times and to motivate readers to take photographs and preserve the history of their present communities. This way, a century from now, folks can take a fond look back and experience life in western Kentucky in the 21st century.

One
HOPKINSVILLE, FORT CAMPBELL, PEMBROKE, FAIRVIEW, CROFTON

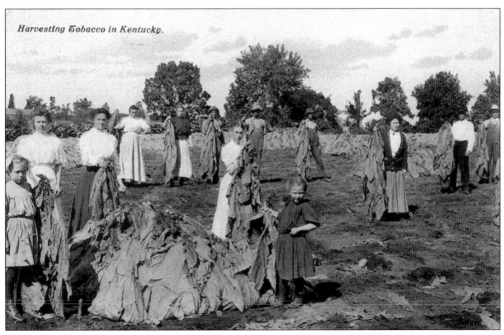

Harvesting Tobacco in Kentucky.

HARVESTING TOBACCO IN KENTUCKY. Our postcard odyssey begins in a tobacco field, which is quite appropriate since the plant has played a major role in the economy of western Kentucky. For many years, the most profitable crop on any farm was tobacco and processing plants were located in nearly every large city. Cutting the crop was often a family affair, as seen here.

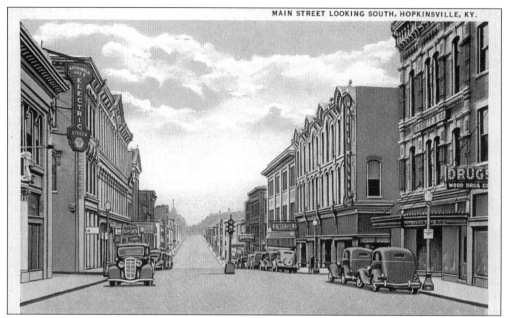

MAIN STREET LOOKING SOUTH, HOPKINSVILLE. Now the largest city in western Kentucky (in terms of population), Hopkinsville is also one of the oldest cities in the region, having been first settled in the late 1700s. During the late 1800s and early 1900s, an impressive array of buildings was constructed downtown, as depicted in this postcard looking south along Main Street at the intersection with Sixth Street.

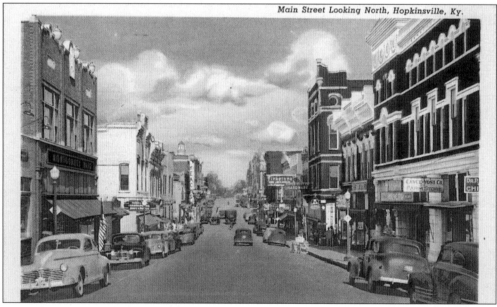

MAIN STREET LOOKING NORTH, HOPKINSVILLE. The vantage point for this postcard is the intersection of Main and Eleventh Streets, five blocks south of the postcard above and looking in the opposite direction. In the 1970s and 1980s, several businesses left downtown in favor of new buildings elsewhere in the city. However, thanks to aggressive action by local preservationists and politicians, most of the buildings seen here are still standing and are still in use.

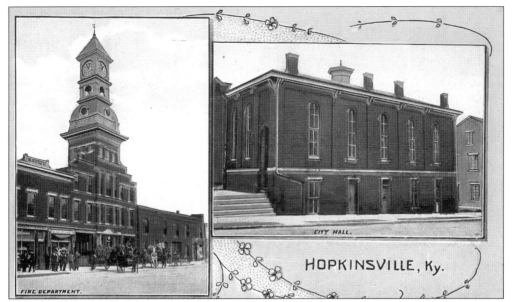

FIRE DEPARTMENT AND CITY HALL, HOPKINSVILLE. This card depicts Hopkinsville's main firehouse and city hall as they appeared around 1910. Located on Ninth Street, the fire hall burned in 1924 and was replaced on the same spot by a building of similar dimensions. In 1964, the fire department moved to a new building, but fortunately, the firehouse was saved and is being restored.

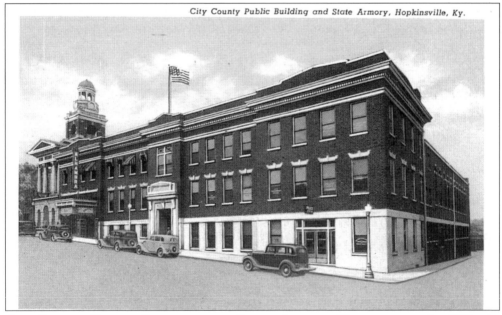

CITY-COUNTY PUBLIC BUILDING AND STATE ARMORY, HOPKINSVILLE. In 1928, the Hopkinsville City Hall seen at the top of the page was demolished and replaced by an annex built next to the Christian County Courthouse at the corner of Main and Fifth Streets. The annex also housed the Hopkinsville city police and state armory. Sandwiched between the county courthouse and the annex is the Alhambra Theater, the first air-conditioned building in Hopkinsville.

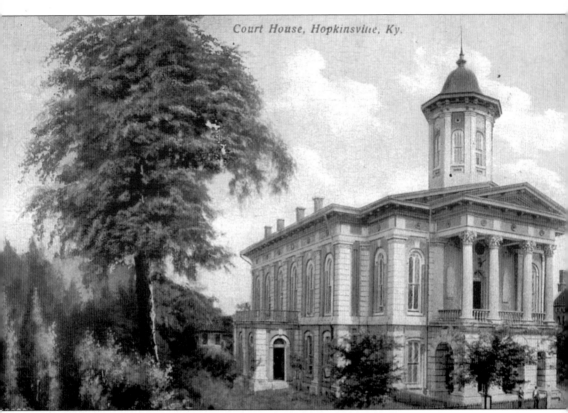

Court House, Hopkinsville, Ky.

CHRISTIAN COUNTY COURTHOUSE, HOPKINSVILLE. In early December 1864, Confederate Gen. H.B. Lyon led 800 troops into western Kentucky in search of supplies and new recruits. On December 12, the troops burned the courthouse in Hopkinsville and the next day torched the courthouse in Cadiz. Then, on December 14, the troops rode in Lyon's hometown of Eddyville, but did not burn the courthouse there because it was located across the street from Lyon's own house. Over the next three weeks, Lyon's troops torched six more courthouses in Kentucky before retreating into Tennessee. During his raid, Lyon "drafted" several hundred new recruits and made them take an oath to show up for duty on January 20, but none did. The Hopkinsville courthouse burned during Lyon's raid was rebuilt in 1869 and this card shows its original appearance. In 1903, the hexagonal cupola was replaced with a square brick cupola, which itself was removed in 1960 due to its condition. The courthouse is still in use today.

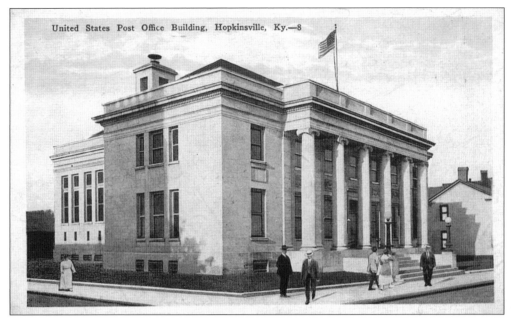

UNITED STATES POST OFFICE, HOPKINSVILLE. During the early 1900s, several new post office buildings were constructed throughout western Kentucky, including this impressive structure in Hopkinsville at the corner of Ninth and Liberty Streets. Constructed in 1914, it served until 1974 when it was replaced by the current post office on North Main Street. Today, the building houses the Pennyroyal Area Museum and a rich collection of artifacts from western Kentucky's history.

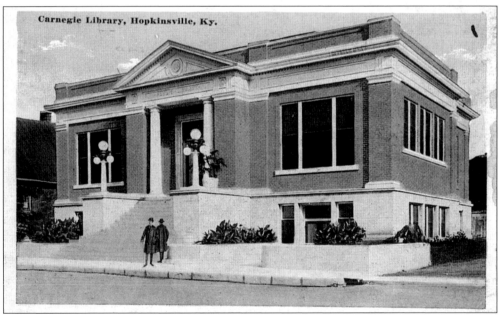

CARNEGIE LIBRARY, HOPKINSVILLE. Construction of the Carnegie Library in Hopkinsville began in December 1913 and was completed in July 1914. Built at the corner of Eighth and Liberty Streets, the library cost approximately $16,500 to build. In 1975, the library relocated to its present building on West Ninth Street, a former wholesale grocery warehouse that was built in 1922.

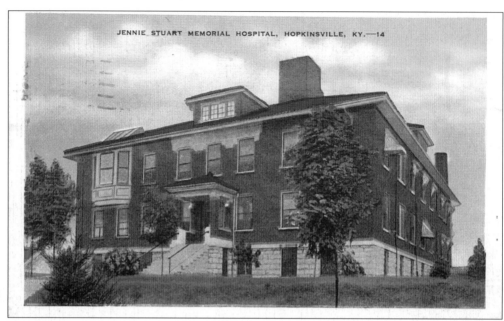

JENNIE STUART MEMORIAL HOSPITAL, HOPKINSVILLE. After the death of his wife, Dr. Edward Stuart spearheaded a drive to build a new hospital in Hopkinsville. Opened in 1914, the hospital was named after Dr. Stuart's wife, Jane "Jennie" Stuart. Construction costs were partly financed by approximately $25,000 that Jennie had saved throughout her life and had hidden in the family home. In 1974, the old hospital was replaced by a new structure.

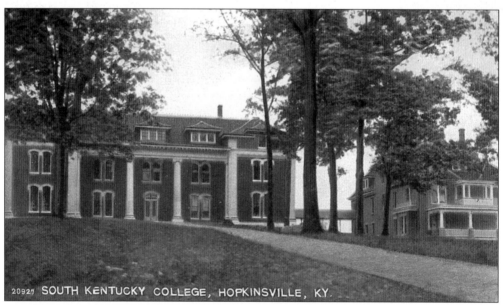

SOUTH KENTUCKY COLLEGE, HOPKINSVILLE. In 1849, South Kentucky College was established as a girl's school on what is now called Belmont Hill. The school eventually changed its name to McLean College to avoid confusion with the many other schools that included "Kentucky" in their names. After burning in 1884, 1905, and 1912, the school closed in 1914 and today the site is occupied by an elementary school.

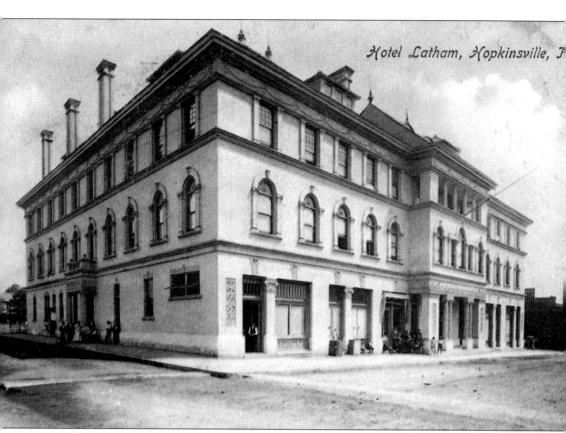

LATHAM HOTEL, HOPKINSVILLE. This elegant three-story hotel at the corner of Seventh and Virginia Streets was built in the early 1890s and named after prominent local businessman John C. Latham, who financed much of the construction costs. The 120-room hotel cost $104,000 to build and was unquestionably the most lavish hotel in Hopkinsville during its era. Alas, it burned on August 4, 1940, was not rebuilt. Today only an empty lot occupies the site. Besides the hotel that bore his name, Latham was involved in many other successful business ventures. Born in 1844, Latham served in the Confederate Army before entering the tobacco and cotton business, eventually moving to New York City in 1870 to establish a cotton brokerage. During the 1890s, Latham invested heavily to build modern roads around Hopkinsville and was a generous donor to his church and local charities. Two parks in Hopkinsville were constructed on land donated by Latham.

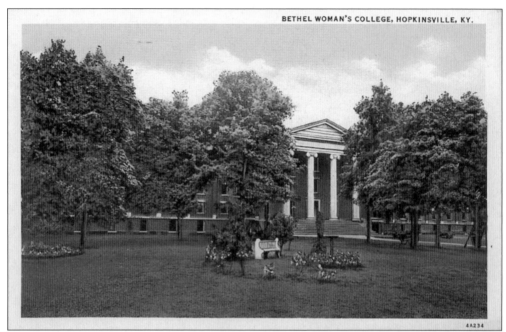

4A234

BETHEL WOMAN'S COLLEGE, HOPKINSVILLE. Founded in 1854 by local Baptist leaders, Bethel Woman's College had several names over the years. The college was housed in this brick building on West Fifteenth Street. It is believed that the building was briefly used as a Confederate hospital during the Civil War. The college became coeducational in 1951, closed in 1964, and was demolished.

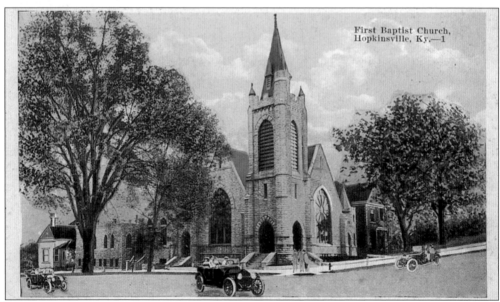

First Baptist Church, Hopkinsville, Ky.—1

FIRST BAPTIST CHURCH, HOPKINSVILLE. Established around 1820, the church constructed the magnificent building shown on this card in 1894. Located at South Main and Fourteenth Streets, the church cost $28,000 and was one of the first buildings in Hopkinsville with electricity. It was demolished in October 1965 and replaced by a new building on an adjacent lot.

16

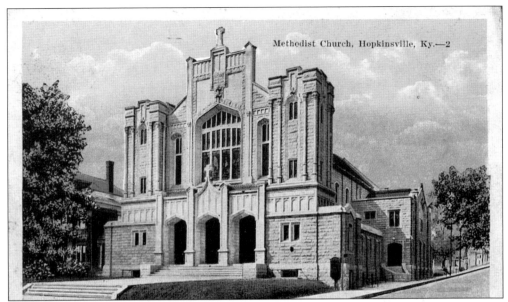

FIRST UNITED METHODIST CHURCH, HOPKINSVILLE. The history of this church dates back to 1786, when a pair of Methodist "circuit riders" made their first visits to Hopkinsville. In 1820, the first Methodist church in Hopkinsville was built at a cost of $200. The present church opened in March 1917 at the corner of Main and Thirteenth Streets. Costing $75,000, the church expanded in 1954 with the construction of an education building.

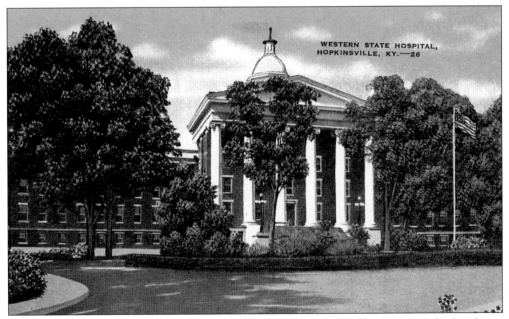

WESTERN STATE HOSPITAL, HOPKINSVILLE. On February 25, 1848, the Kentucky legislature passed an act calling for the establishment of the Western Lunatic Asylum, to be located about two miles east of downtown Hopkinsville. After a fire destroyed many of the original buildings of the asylum on November 30, 1861, this elegant three-story structure was constructed. Now renamed Western State Hospital, the institution is still operating and can be seen along US 68.

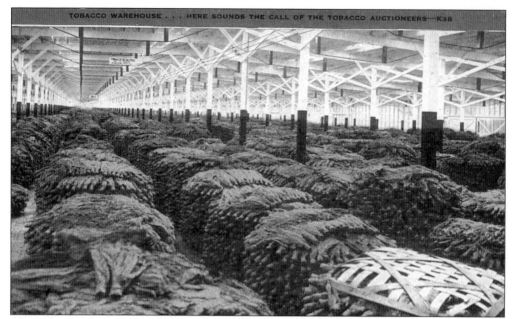

TOBACCO WAREHOUSE. Beginning in 1869, when the first tobacco warehouse was built in the city, Hopkinsville served as a major sales and marketing center for tobacco in western Kentucky. There were nearly a dozen large warehouses where farmers could sell their crops, and three processing plants were once in operation. Most of the warehouses are now closed and only one processing plant remains.

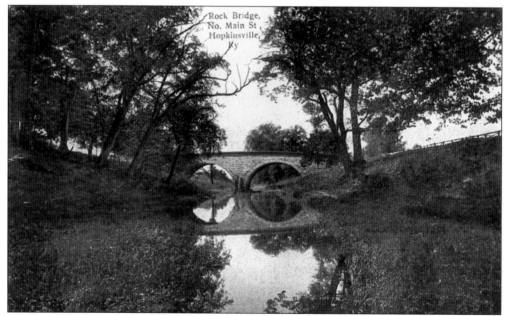

ROCK BRIDGE, HOPKINSVILLE. On the north side of Hopkinsville is this rock bridge that carries North Main Street over Little River. This particular bridge is still in service and today carries the southbound lanes of US41 into Hopkinsville, while a newer bridge nearby carries the northbound lanes.

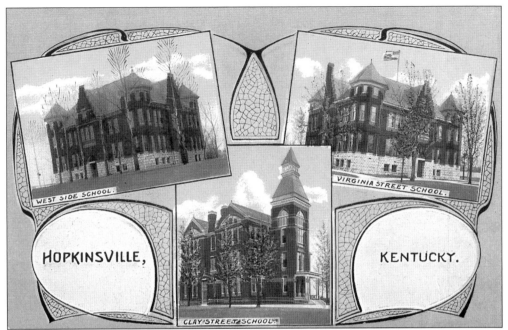

Three Public Schools, Hopkinsville. The three schools depicted on this card were all built in the early 1880s, shortly after the public school system in Hopkinsville was organized. West Side School and Virginia Street School, on the top row, served white students. Clay Street School, on the bottom, served the city's black students. The city school system was segregated until 1967.

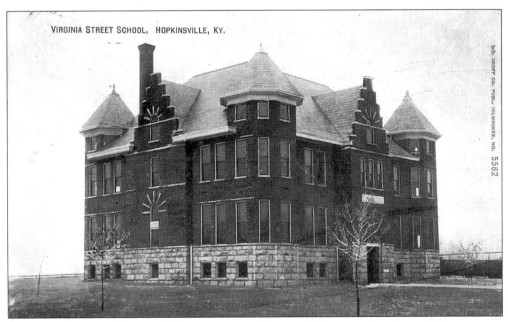

Virginia Street School, Hopkinsville. Large windows—to let in sunlight—were a requirement for Hopkinsville's early school buildings, since electric lighting had not yet been installed in the city when the schools were built. The building was heated by a coal or wood furnace and, of course, lacked any air conditioning.

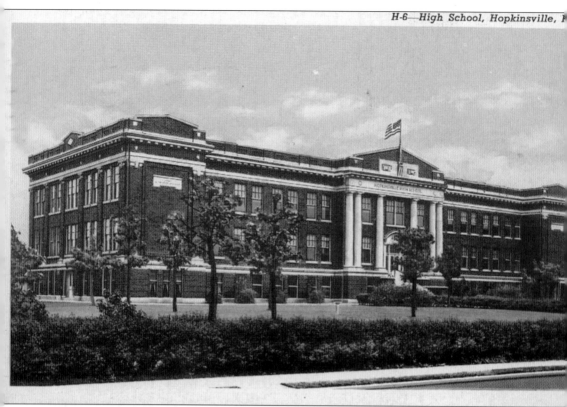

HIGH SCHOOL, HOPKINSVILLE. During the 1910s, all three schools seen on the last page were demolished and replaced with new schools. The building shown on this card was constructed in 1912 on Walnut Street and served the city's white high school students. In 1963, the present Hopkinsville High School opened on Koffman Drive across town and afterwards this building served as a middle school. Following desegregation in 1967, the school admitted black students. In 1976, the middle school students moved to the current Hopkinsville Middle School on Koffman Drive, next to the high school. The building was then demolished. The football stadium behind this school continued to be used until 1991 when it was replaced by a new stadium off Lafayette Road. The old stadium still stands and is used as a community center.

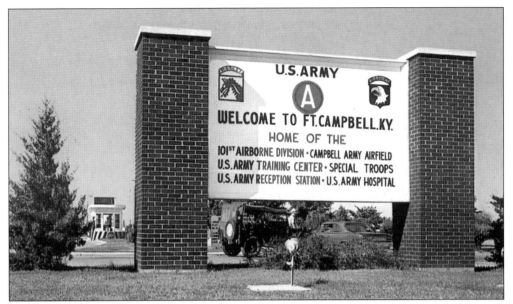

WELCOME SIGN, FORT CAMPBELL. On July 16, 1941, Camp Campbell, Kentucky, was established as a temporary wartime training facility on 170,000 acres of former farmland along the Kentucky-Tennessee border, about 15 miles south of Hopkinsville. The military's original intent was to deactivate the base after World War II, but in April 1950, it was designated as a permanent base and renamed Fort Campbell.

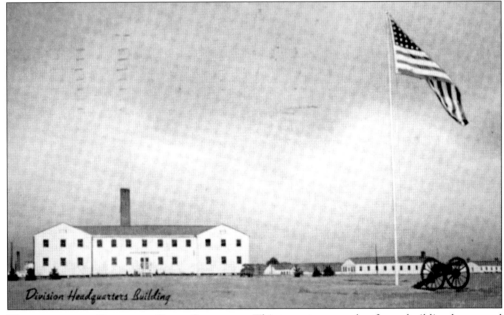

HEADQUARTERS BUILDING, CAMP CAMPBELL. This two-story wooden frame building has served as the headquarters building for Fort Campbell ever since the base was founded. Most buildings constructed during the early years of Camp Campbell were simple wooden structures identical to the ones seen here, since the base was initially planned as a temporary facility. Many of the wooden buildings remain in use, some 60 years after their construction.

21

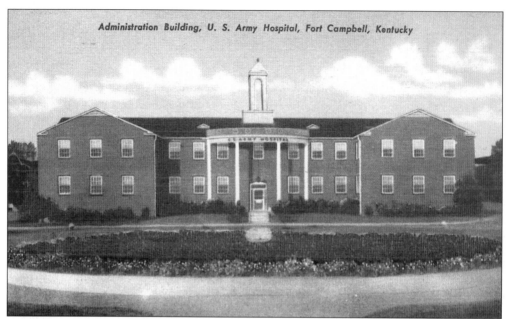

Administration Building, U. S. Army Hospital, Fort Campbell, Kentucky

ADMINISTRATION BUILDING, UNITED STATES ARMY HOSPITAL, FORT CAMPBELL. The first hospital at Fort Campbell was not a single building, but rather 53 buildings containing over 7.5 miles of corridors and occupying approximately 72 acres of land. A new hospital was completed in 1982, but most of the old hospital buildings, including the administration building seen here, are still in use for other purposes.

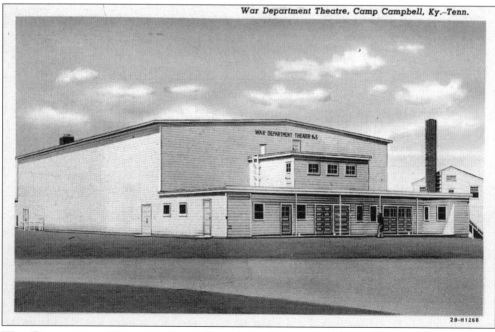

War Department Theatre, Camp Campbell, Ky.–Tenn.

WAR DEPARTMENT THEATER, CAMP CAMPBELL. During World War II, tens of thousands of troops moved through Camp Campbell for training and eventual deployment overseas. A variety of theaters and clubs were constructed to entertain the troops, including the theater seen here.

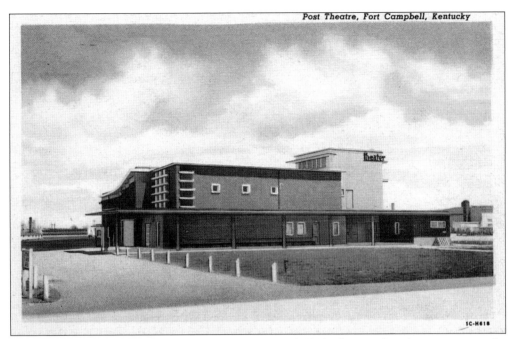

Post Theatre, Fort Campbell, Kentucky

POST THEATER, FORT CAMPBELL. Sometime around 1950, the wooden theater seen on the previous page was replaced by a newer theater. The author lived at Fort Campbell as a child during the early 1970s and this is the first theater that he recalls going to. As of mid-2002 the theater was still operating.

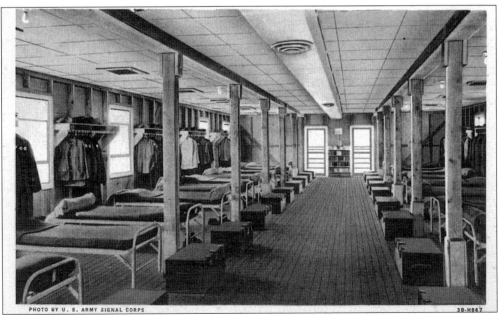

PHOTO BY U. S. ARMY SIGNAL CORPS

INTERIOR OF A TYPICAL BARRACK, FORT CAMPBELL. An unknown soldier wrote in pencil on the back of this card, "This is how our barricks [sic] looked in basic training but now we have wall locker to put our clothing in, so no one can steal them." In addition to barracks for single soldiers, Fort Campbell provides housing for the families of several thousand soldiers.

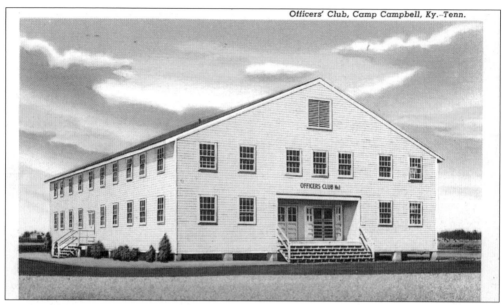

Officers' Club, Camp Campbell, Ky.–Tenn.

OFFICERS CLUB No.1

OFFICERS' CLUB, FORT CAMPBELL. A centuries-old military tradition holds that officers and enlisted men do not socialize together. For this reason, military bases have both an Officers' Club and a Non-Commissioned Officers' (NCO) club for recreation. Seen here is the original Officers' Club at Fort Campbell, which has since been replaced with a more attractive building surrounded by tennis courts and a golf course.

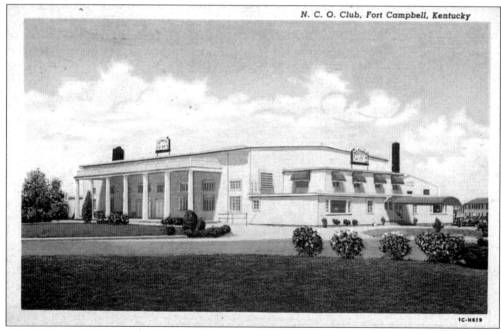

N. C. O. Club, Fort Campbell, Kentucky

1C-H619

NON-COMMISSIONED OFFICERS CLUB (NCO) AT FORT CAMPBELL, KENTUCKY. The NCO Club at Fort Campbell is smaller but a bit more elegant than the original Officers' Club seen above. Built in the mid-1940s, it is still in use today and remains a popular gathering spot for enlisted men.

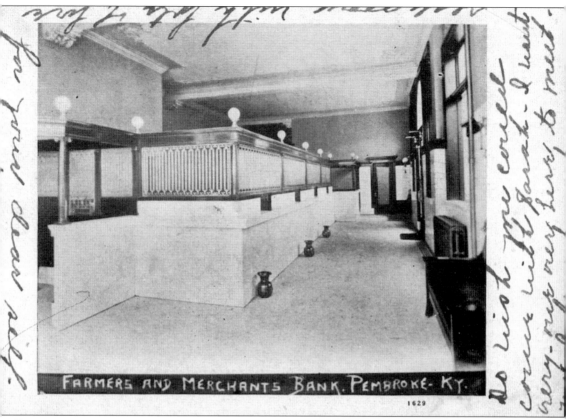

FARMERS AND MERCHANTS BANK, PEMBROKE. **FARMERS AND MERCHANTS BANK, PEMBROKE.** This card, postmarked June 1909, provides a glimpse at the brass spittoons and the fancy teller cages inside the Farmers and Merchants Bank building in downtown Pembroke. The bank opened in 1898 inside a two-story building that hosted a doctor's office and telephone exchange on the second floor. In 1913, the bank closed and was replaced by a general store. The building burned a few years later.

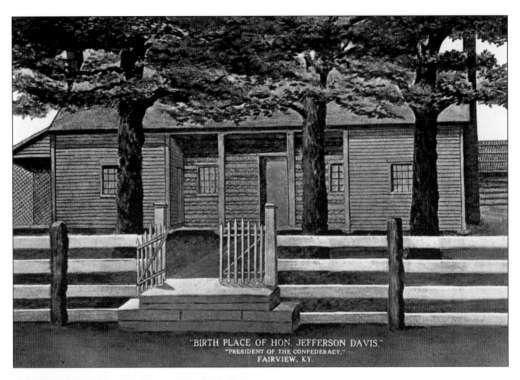

"BIRTH PLACE OF HON. JEFFERSON DAVIS,"
"PRESIDENT OF THE CONFEDERACY,"
FAIRVIEW, KY.

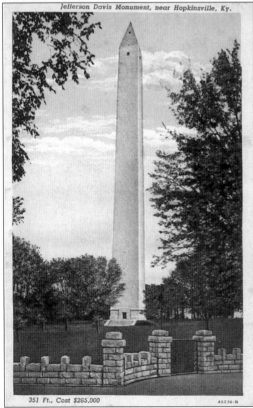

Jefferson Davis Monument, near Hopkinsville, Ky.

351 Ft., Cost $265,000

JEFFERSON DAVIS BIRTHPLACE, FAIRVIEW. Jefferson Davis, the first and only president of the Confederate States of America, was born June 3, 1808 in Fairview, Kentucky. This postcard, featuring a painting done around 1950, shows what the Davis family cabin may have looked like at the time of Davis's birth. Some of the cabin windows had glass windows, a real rarity at the time.

JEFFERSON DAVIS MONUMENT STATE PARK, FAIRVIEW. After Davis's death on December 5, 1889, several groups formed a plan to build a monument in Fairview to honor him. Construction of a concrete obelisk began in 1917, was halted between 1918 and 1922, and was finally completed in 1924. The monument, now part of a state park, stands 351 feet tall and is said to be the world's tallest concrete obelisk.

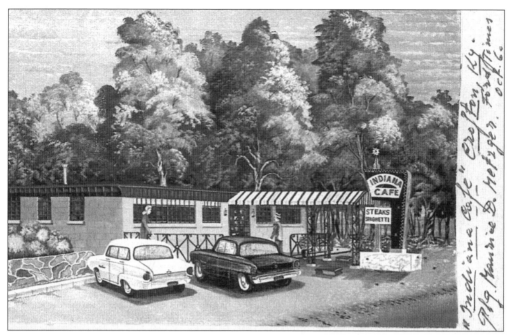

INDIANA CAFÉ, CROFTON. During the late 1950s and early 1960s, local artist Maurice D. Metzger published several postcards depicting local landmarks. These postcards featured reproductions of Metzger's own paintings that were carefully cut apart and then pasted on a standard postcard. One such card shows the Indiana Café in Crofton, about 12 miles north of Hopkinsville.

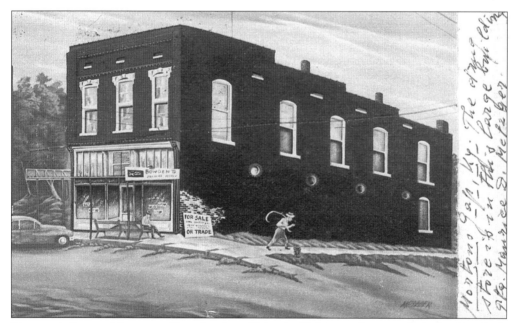

BOWDEN'S STORE, MORTONS GAP. Another of Maurice D. Metzger's postcards depicts Bowden's Store in Mortons Gap, about 15 miles north of Crofton. The handwritten caption says, "The drug store is in this large building."

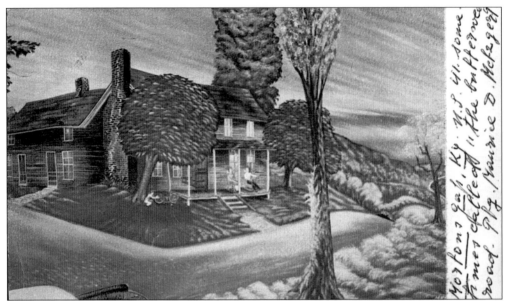

FARMHOUSE, MORTONS GAP. An aging two-story farmhouse along US41 near Mortons Gap is the focus of this Maurice D. Metzger card. The caption says that US41 is sometimes called the "Butterwell Road." Actually, the name was the "Buttermilk Road." According to local legend, the road gained this name because farmers would set out pitchers of buttermilk for travelers.

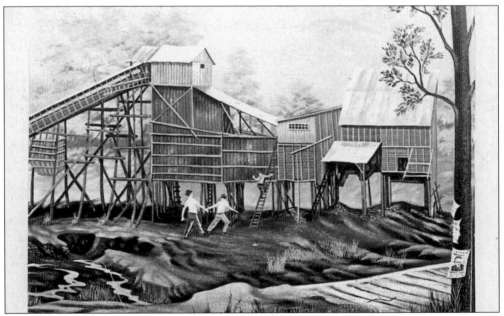

COAL TIPPLE, MORTONS GAP. Although most are now closed, dozens of coal mines of all sizes once operated in the area around Mortons Gap. Some mines only produced a few tons daily while others could fill an entire train. In this view, two men seem to be attempting to coax a less adventuresome friend into joining them as they explore an abandoned tipple.

Two
CENTRAL CITY, PARADISE, GREENVILLE, GUTHRIE

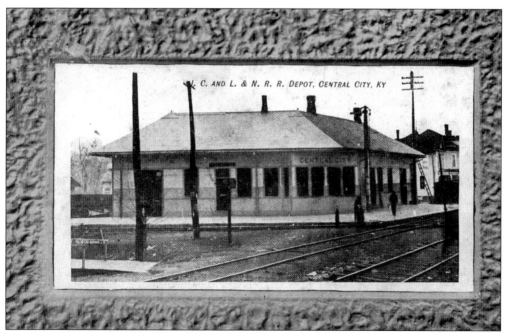

C. AND L. & N. R. R. DEPOT, CENTRAL CITY, KY

DEPOT, CENTRAL CITY. Our postcard odyssey begins in Central City, deep in the western Kentucky coalfields. To transport the coal from the mines to market, several railroads were built throughout the region. At Central City, the Illinois Central Railroad (ICRR) and the Louisville and Nashville Railroad shared this L-shaped depot. In the mid-1920s, the ICRR elevated its track through Central City and this depot was demolished.

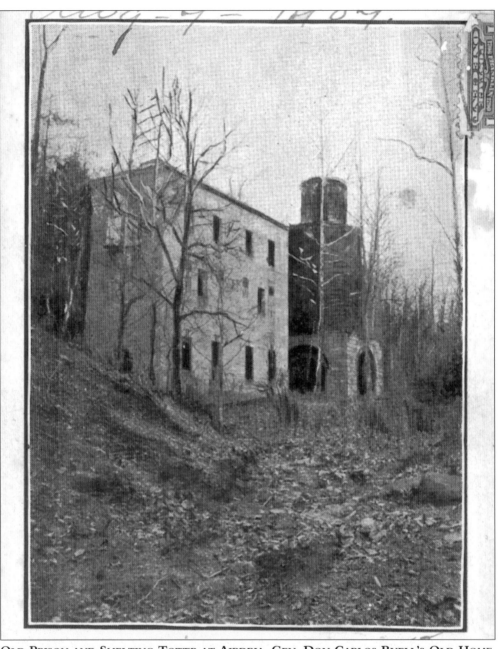

OLD PRISON AND SMELTING TOWER AT AIRDRIA, GEN. DON CARLOS BUELL'S OLD HOME, PARADISE. Throughout western Kentucky, many towns once prospered but are now just a memory. One of these is Paradise, along the banks of the Green River in Muhlenberg County. In the mid-1960s, the residents of Paradise were uprooted by the Tennessee Valley Authority, which built a coal-fired power plant on the site. John Prine immortalized Paradise and its destruction in his 1971 song "Paradise." The "old prison" that is mentioned in Prine's song is shown in the postcard above. Actually, it never was a prison. When the Eddyville penitentiary was built in the 1880s, much of the limestone was quarried near Paradise and the building above was constructed as temporary living quarters for the prison laborers brought to work at the quarry.

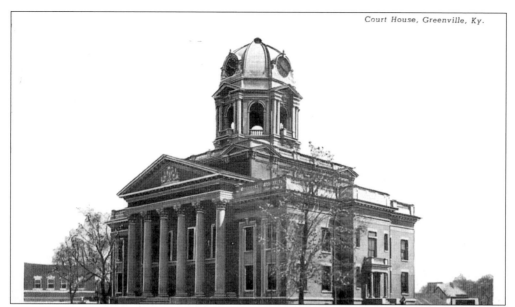

MUHLENBERG COUNTY COURTHOUSE, GREENVILLE. Originally a part of Virginia, statehood was granted to Kentucky on June 1, 1792. From the original nine counties, the state was eventually carved up into 120 counties. Muhlenberg County was formed on May 15, 1798 from parts of Christian and Logan Counties, and the county seat is Greenville. The present courthouse was completed in 1908 and cost $88,000.

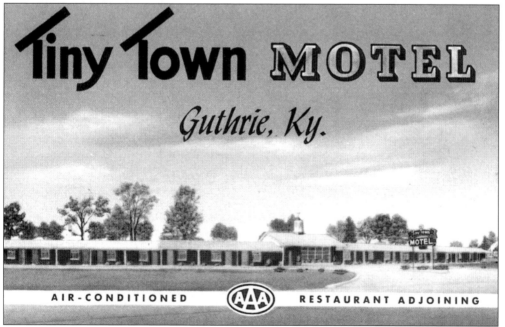

TINY TOWN MOTEL, GUTHRIE. Before the construction of interstate highways, two of the busiest highways in western Kentucky were US highways 41 and 79. These two roads intersected a mile north of Guthrie at a location called Tiny Town, where this motel was built. Although just a garden-variety motel, it is still remembered—thanks to the peacocks that once lived there.

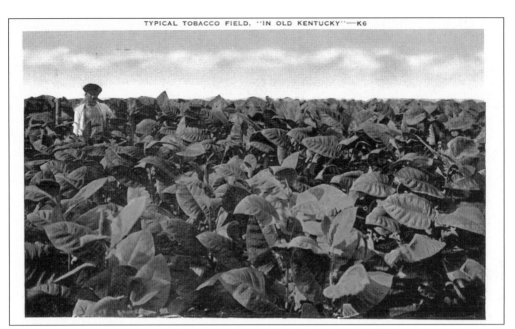

TOBACCO FIELD. Since its introduction to Kentucky during the mid-1700s, tobacco has been a major source of income to Kentucky farmers. As illustrated by the postcard on the front cover, whole families—including women and children—were often involved in the growing process. Most of the larger towns had at least one warehouse where farmers would take their tobacco to be sold to tobacco processors.

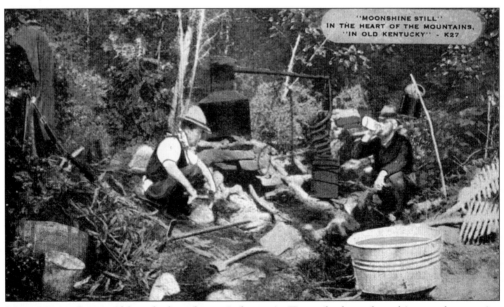

MOONSHINE STILL. Although the tobacco industry in Kentucky has a long history, the practice of distilling corn into "moonshine" is even older. The moonshine industry reached its peak during Prohibition, when hundreds of stills were secretly built all across the region to fulfill the neverending demand for alcohol. As attested by the rifle to the left, these stills were usually heavily guarded.

Three
MADISONVILLE, DIXON, STURGIS

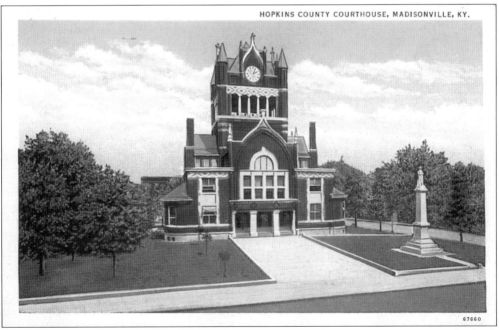

HOPKINS COUNTY COURTHOUSE, MADISONVILLE. Formed in 1806, Hopkins County has built six different courthouses during its long history. The first courthouse was built in 1807 at a cost of $329. New courthouses were built in 1825, 1840, and 1866, before the courthouse seen on this card was built in 1892. This building was torn down in 1935 to make way for the present courthouse.

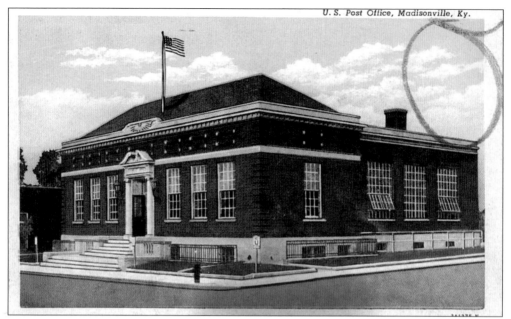

UNITED STATES POST OFFICE, MADISONVILLE. The first post office in Madisonville opened in 1809 and was originally named Hopkins Courthouse, after the county in which Madisonville is located. Around 1925, the post office relocated to this stately building along Main Street, and remained there until moving to a new building in 2000. The building now houses county offices.

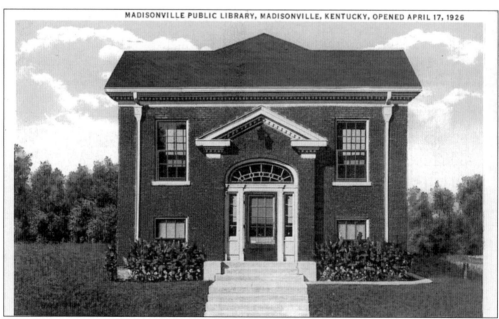

MADISONVILLE PUBLIC LIBRARY, MADISONVILLE, KENTUCKY, OPENED APRIL 17, 1926

MADISONVILLE PUBLIC LIBRARY. During the first five years of its existence, the Madisonville Public Library was housed in a shop at the corner of South Main and Bishop Streets. Then on April 17, 1926, the library moved to this two-story brick structure at 107 Union Street. The library moved again in February 1975 to South Main Street, and afterwards the Hopkins County Historical Society took over the old library.

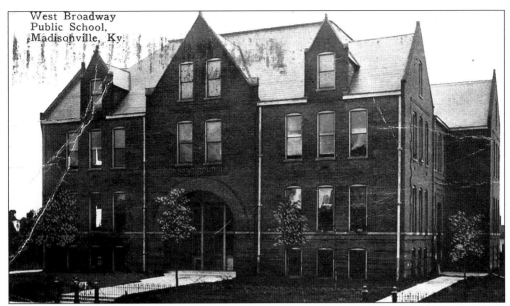

WEST BROADWAY PUBLIC SCHOOL, MADISONVILLE. Public schooling in Madisonville began around 1889 in buildings rented throughout the city. In late 1903, the school district constructed its first building, shown on this card. Originally called Madisonville Grade School, the school eventually became known as West Broadway School for its location. In 1937 and 1955, the school was remodeled and expanded and still stands but it is on longer used as a school.

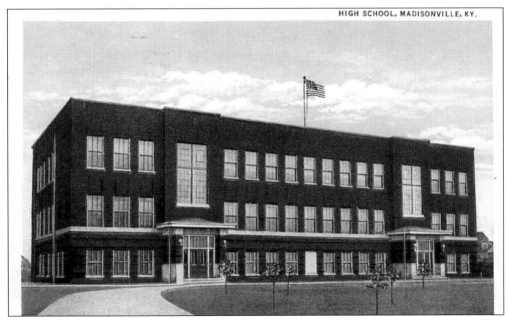

HIGH SCHOOL, MADISONVILLE. In 1923, high school students in Madisonville began attending this three-story school on South Seminary Street. The building had 16 classrooms, 2 study rooms, and an auditorium. In 1938, the high school students moved again to a new building at Arch and Spring Streets and up until 1979, the building was used as a middle school. It then became home to the central offices of the county school district.

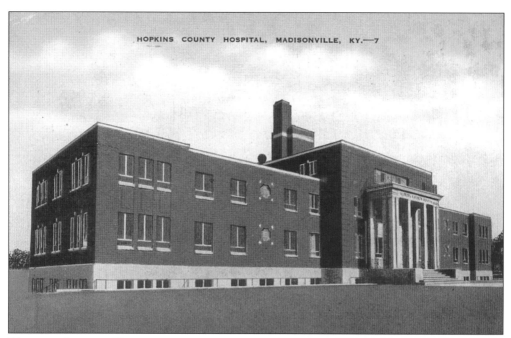

HOPKINS COUNTY HOSPITAL, MADISONVILLE. Today, Madisonville is served by the Regional Medical Center, a modern hospital equipped with state-of-the-art technology and staffed by excellent doctors. The predecessor of this hospital was the Hopkins County Hospital, seen here. This brick building, located a few hundred yards from the new hospital, is still standing and serves as the headquarters for the Trover Foundation.

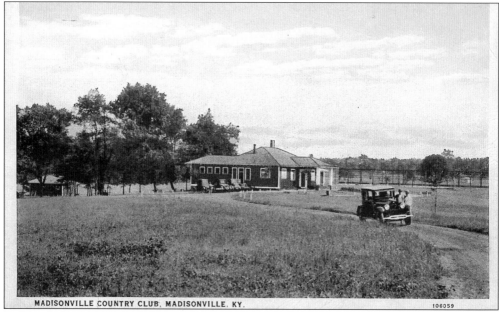

MADISONVILLE COUNTRY CLUB, MADISONVILLE, KY. 106059

MADISONVILLE COUNTRY CLUB. The country club was constructed off South Main Street a few miles south of Madisonville around 1921. Over the years, the country club has expanded but it remains in its original location.

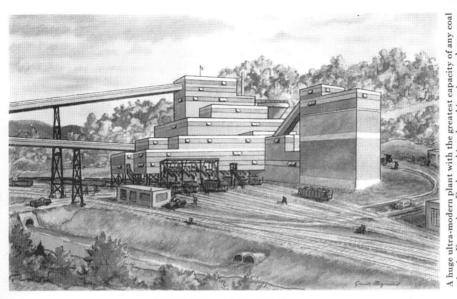

A huge ultra-modern plant with the greatest capacity of any coal mine in Kentucky. Each working day this mine produces over 150 cars of ▆▆▆▆ washed coal. Largest mine in the West Kentucky Coal Company group.

HOMESTEAD MINE

HOMESTEAD MINE, MADISONVILLE. Beginning in the late 1800s, coal mining emerged as the dominant industry in and around Madisonville. One of the largest mines was the Homestead Mine south of Madisonville. This mine was operated by the West Kentucky Coal Co., one of the largest coal operators in western Kentucky. According to the caption on this card, the Homestead mine could fill over 150 rail cars each working day.

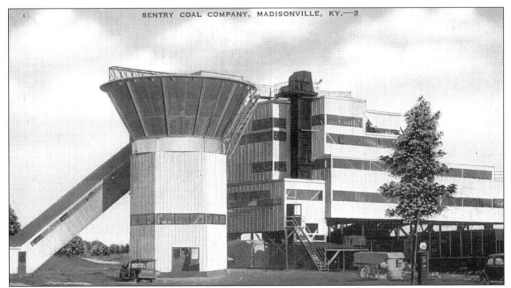

SENTRY COAL COMPANY, MADISONVILLE, KY.—2

SENTRY COAL CO., MADISONVILLE. Most coal from western Kentucky has a high sulfur content, and when burned, releases gases believed to harm the environment. To stem this environmental damage, numerous new regulations and laws were passed in the 1970s and 1980s. This brought about the closure of most coal mines in western Kentucky, including the Sentry mine near Madisonville.

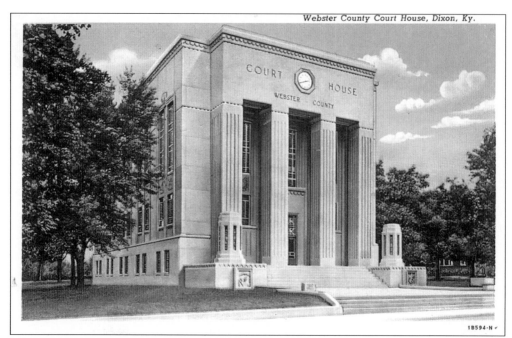

WEBSTER COUNTY COURTHOUSE, DIXON. Most courthouses in western Kentucky were built using bricks, but the present Webster County Courthouse was constructed of poured concrete. The building was constructed in 1939–1940 by the Work Projects Administration at a cost of approximately $143,000. Webster County was formed in 1860 from parts of Henderson, Hopkins, and Union Counties, and was named after the famed statesman Daniel Webster.

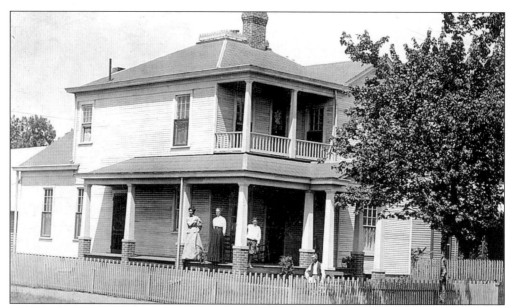

FAMILY IN FRONT OF HOME, STURGIS. Although it is not marked as such, this house is believed to be in Sturgis, in Union County. Unfortunately, neither the family's name nor the street address of this house is known. Until the 1980s, coal mining was the dominant industry around Sturgis. Today, most of the coal mines are silent.

Four
HENDERSON

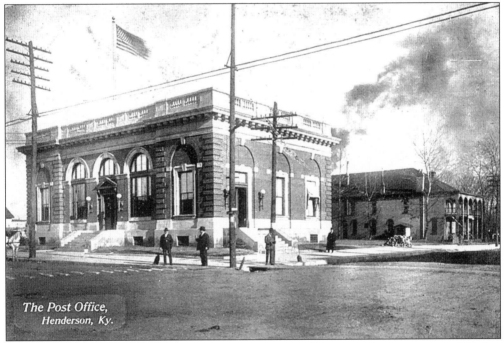

The Post Office,
Henderson, Ky.

POST OFFICE, HENDERSON. Established in 1801, the post office at Henderson was one of the first in western Kentucky. The building seen here was constructed around 1905 and provides an interesting view of life in Henderson in early 1900s. No automobiles are to be seen, just a single horse-drawn carriage at the far left. Poles carrying electrical, telegraph, and phone cables dominate the scene.

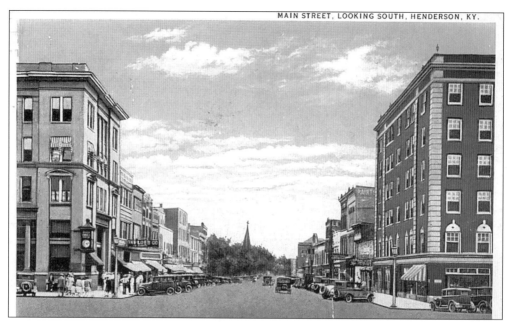

MAIN STREET LOOKING SOUTH, HENDERSON. Henderson is now the second-largest city in western Kentucky in terms of population, behind Hopkinsville and just ahead of Paducah. Streetcars once roamed throughout the city but the Great Depression and a growing number of private cars combined to eliminate that service. Thanks to local preservationists, several of the buildings seen here still survive. A portion of the Hotel Soaper is visible to the right (see below).

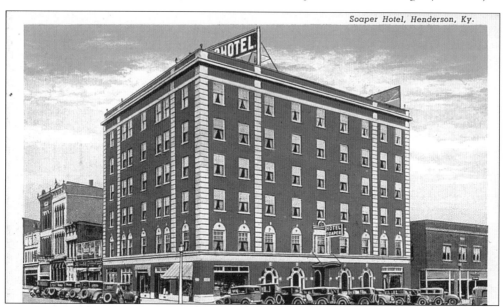

Soaper Hotel, Henderson, Ky.

HOTEL SOAPER, HENDERSON. In 1924, a prominent local tobacco man, Richard Henderson Soaper, spent $285,000 to construct the finest hotel built in Henderson up to that time. Hotel Soaper stood at the corner of Main and Second Streets. The six-story brick building had 104 guest rooms, a ballroom, beauty and barbershops, and even a drug store. Today it is the headquarters for Western Kentucky Energy Corp.

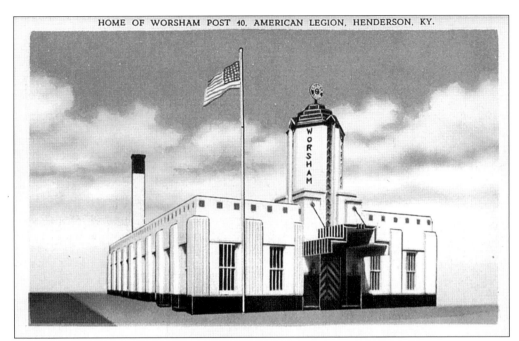

AMERICAN LEGION POST 40, HENDERSON. Located at 215 North Elm Street, this building was constructed around the early 1930s and is still in use. The unique tower and entry canopy both survive.

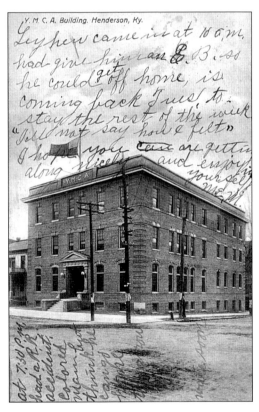

YMCA BUILDING, HENDERSON. Today the YMCA is often regarded as just a place to go and exercise. During the early 1900s, the "Y" was much more than just a gym—it also provided room and board for men passing through town. Railroad crews, in particular, were frequent patrons, because the Y's were typically cleaner than the boarding halls that catered to out-of-town train crews.

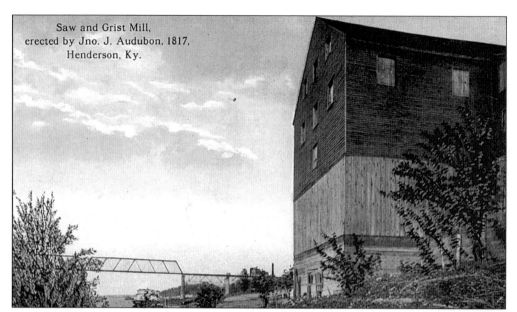

AUDUBON SAW AND GRIST MILL, HENDERSON. Perhaps the most famous person to ever live in Henderson was John James Audubon, the famed 19th-century artist whose detailed drawings of birds attracted worldwide attention. Audubon lived briefly in Henderson between 1810 and 1820. During this time, Audubon engaged in several different business activities, including the sawmill seen here. All failed, however, since Audubon spent most of his time on his art.

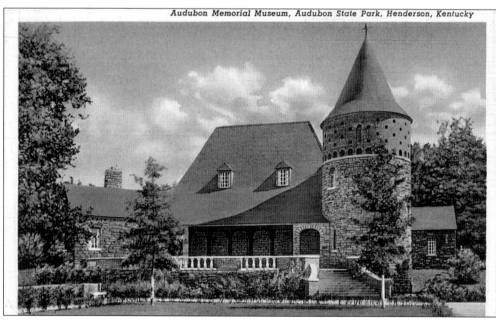

AUDUBON NATURE CENTER, HENDERSON. The state of Kentucky honored John Audubon by creating Audubon State Park in Henderson. Covering 692 acres, the park includes some of the woodlands where Audubon made many of his drawings. The center point of the park is the Audubon Nature Center, built in the 1930s by the Work Project Administration (WPA). Numerous original drawings are on display inside.

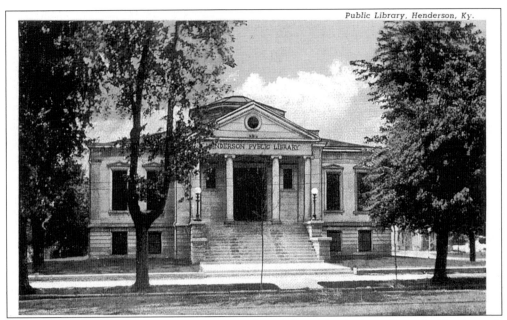

HENDERSON PUBLIC LIBRARY. With assistance from industrialist Andrew Carnegie, Henderson's public library opened on August 1, 1904, in this elegant building at the corner of Main and Washington Streets. When first opened, the library was segregated, with white residents having access to 500 books and black residents having access to 100 books. The library remains at its original location, having been renovated and enlarged several times.

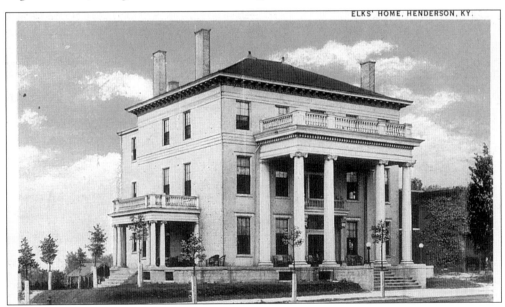

ELK'S HOME, HENDERSON. Founded in February 1868, the Benevolent and Protective Order of Elks has established lodges in over 2,000 towns and cities across the United States, including several in western Kentucky. This fraternal organization is heavily involved in assisting the needy, as demonstrated by the many homes constructed to house the needy and elderly. The Elks' Home in Henderson has closed but the organization still has a lodge in town.

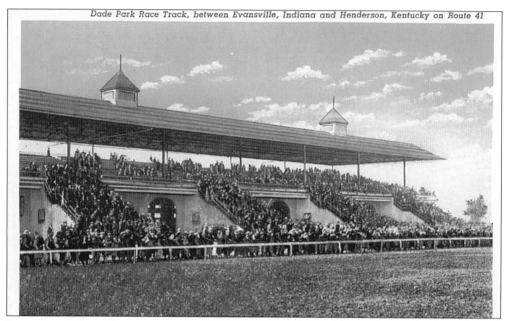

DADE PARK RACE TRACK, HENDERSON. Although horse racing and breeding is big business in central Kentucky, only a handful of horse tracks have been built in western Kentucky. One of these is Ellis Park near Henderson, opened in 1922 and originally known as Dade Park. The track offers live racing in the summer and year-round betting on races simulcast from around the nation.

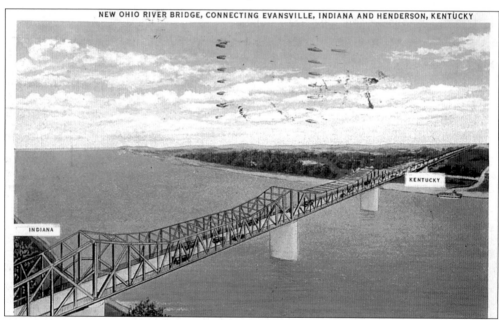

NEW OHIO RIVER BRIDGE, CONNECTING EVANSVILLE, INDIANA AND HENDERSON, KENTUCKY

US41 BRIDGE OVER OHIO RIVER, HENDERSON. Before the late 1920s, there were no highway bridges over the Ohio River in western Kentucky. Then on May 8, 1929, the Irvin Cobb (US45) Bridge opened between Paducah, Kentucky, and Brookport, Illinois, followed on July 3, 1932 by the Audubon Memorial (US41) Bridge between Henderson and Evansville, Indiana. In the mid-1960s, a second bridge was built parallel to the original Henderson-Evansville Bridge.

44

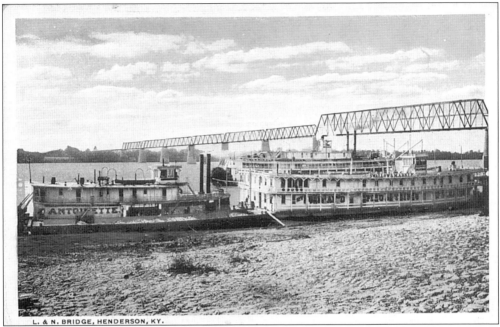

L. & N. BRIDGE, HENDERSON, KY.

LOUISVILLE AND NASHVILLE RAILROAD BRIDGE, HENDERSON. Three railroad bridges cross the Ohio River in western Kentucky. The first to be constructed was built at Henderson by the Louisville and Nashville Railroad (L&N). Completed on July 13, 1885, the bridge took a year to construct and cost approximately $2,000,000. Before the bridge was completed, freight cars and passenger cars were ferried across the river.

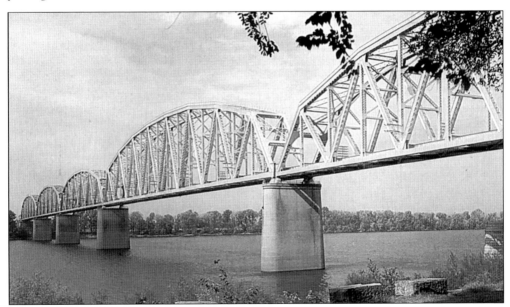

NEW LOUISVILLE AND NASHVILLE RAILROAD BRIDGE, HENDERSON. By the 1930s, the L&N had purchased locomotives and cars that were too heavy for the old Henderson Bridge. To remedy the solution an all-new bridge was built at a cost exceeding $3,000,000. The new bridge opened on December 31, 1932, and afterwards the old bridge was torn down.

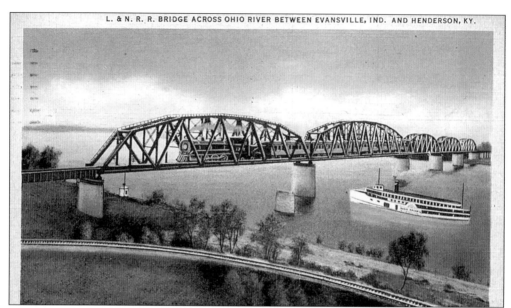

PASSENGER TRAIN CROSSING LOUISVILLE AND NASHVILLE RAILROAD BRIDGE, HENDERSON. During the heyday of passenger trains, it was common for a dozen or more passenger trains to cross the Henderson Bridge each day. These trains carried many thousands of passengers each year. One of these passengers was the notorious gangster Al Capone, who crossed the bridge in May 1932, while en route from Chicago to the federal prison in Atlanta.

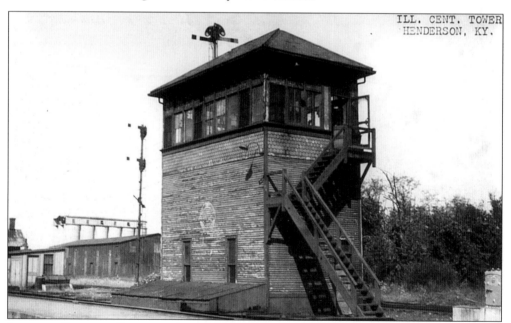

ILLINOIS CENTRAL RAILROAD INTERLOCKING TOWER, HENDERSON. In 1893, the Illinois Central Railroad reached Evansville, Indiana, and in 1896, the ICRR reached Henderson (just across the Ohio River from Evansville). Rather than building its own bridge to connect these cities, the ICRR struck a deal to use the L&N's bridge between Henderson and Evansville. This two-story interlocking tower controlled the junction of ICRR's and L&N's trackage in Henderson.

Five

MORGANFIELD, MARION, PRINCETON, DAWSON SPRINGS

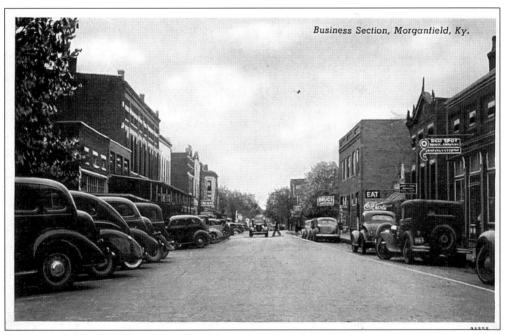

BUSINESS DISTRICT, MORGANFIELD. Advertising signs for a hardware store, a restaurant, and two drug stores are visible in this view of Morganfield's downtown district. In 1942, Camp Breckinridge was established just east of Morganfield as a training center for United States Army recruits. The base was deactivated in 1962 and the base's 35,000 acres were sold for use as farmland, mining, and a Job Corps training center.

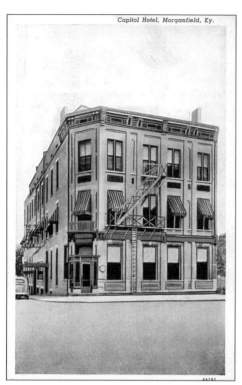

Capitol Hotel, Morganfield, Ky.

CAPITOL HOTEL, MORGANFIELD. In 1941, Morganfield was served by two passenger trains that traveled the ICRR between Evansville, Indiana, and Princeton, Kentucky. The city also boasted of a library, local taxi service, and two hotels, including the Capitol Hotel, seen above. Today both the train tracks and the Capitol Hotel are just a memory.

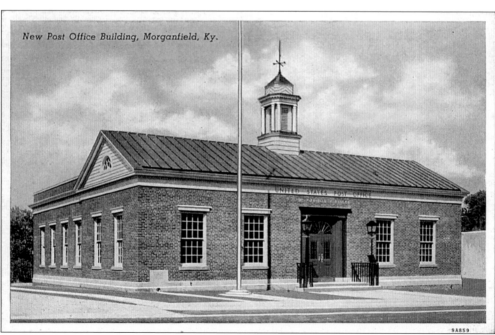

New Post Office Building, Morganfield, Ky.

NEW POST OFFICE, MORGANFIELD. The first post office in Morganfield was established March 23, 1813, only about 20 years after settlers began moving into western Kentucky. In July 1937, the post office moved into this single-story brick building. Located on North Main Street, the building cost $60,000 to construct.

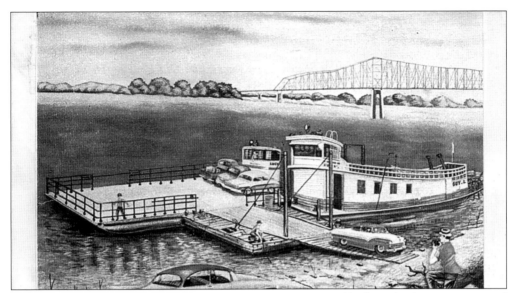

SHAWNEETOWN FERRY, OHIO RIVER. Before the construction of highway bridges, motorists and pedestrians had to use ferries to cross the Ohio River. One ferry was located at Shawneetown, Illinois, about 30 miles downstream from Henderson. The ferry ceased operations in the early 1960s after a new highway bridge over the river opened at Shawneetown. In this view, the nearly-completed bridge is visible behind the ferry.

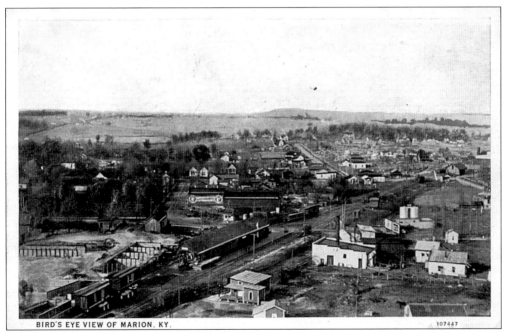

BIRD'S EYE VIEW OF MARION, KY.

107447

BIRD'S-EYE VIEW, MARION. The city of Marion was founded in 1842 and named after Francis Marion, the so-called "Swamp Fox" hero of the American Revolution. The town's growth was fueled by the opening of several mines to produce fluorspar, used in the production of steel, fertilizer, and many other products. During the Civil War, the courthouse in Marion was burned by Confederate Gen. Hylan B. Lyons, who also burned the Hopkinsville courthouse (page 12).

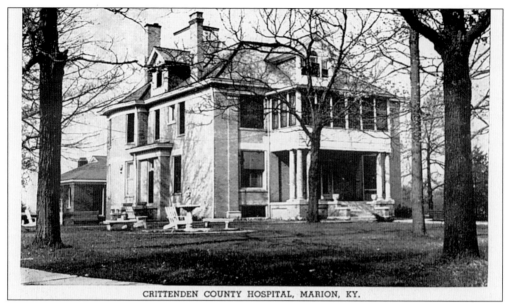

CRITTENDEN COUNTY HOSPITAL, MARION, KY.

CRITTENDEN COUNTY HOSPITAL, MARION. Many early hospitals in western Kentucky were almost indistinguishable from a private residence. At Crittenden County Hospital, patients could rest either on the second floor screened-in porch or on one of the many chairs in the front yard. This building has since been replaced by a new hospital stocked with equipment unheard of when this old building was constructed.

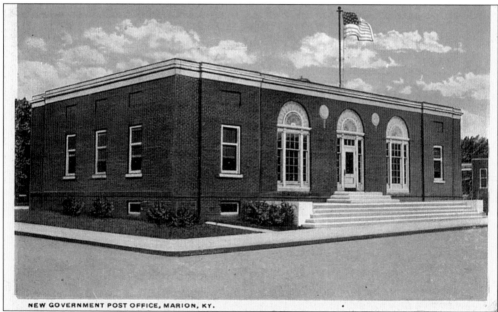

NEW GOVERNMENT POST OFFICE, MARION, KY.

POST OFFICE, MARION. Completed in the mid-1920s, the Marion Post Office was just one of several new post offices built throughout western Kentucky in the early 1900s. The handwritten message on the back tells how the sender took the train from her home in Paducah to Marion. In 1930, when the card was mailed, the ICRR still operated two passenger trains daily through Marion.

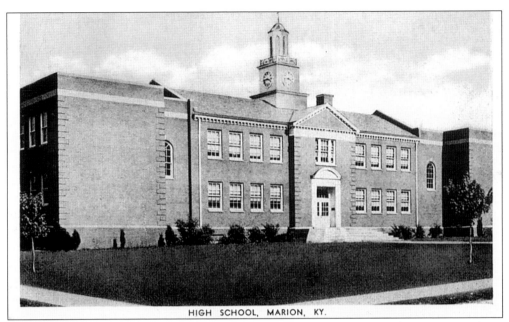

HIGH SCHOOL, MARION, KY.

MARION HIGH SCHOOL, MARION. The first public school in Marion was the Marion Academy and Normal School, which opened in 1886 on donated land. Over the years, several fine schools have been constructed, including Marion High School along Walker Street. This building has since been replaced by a new high school on West Gum Street and is presently sitting empty.

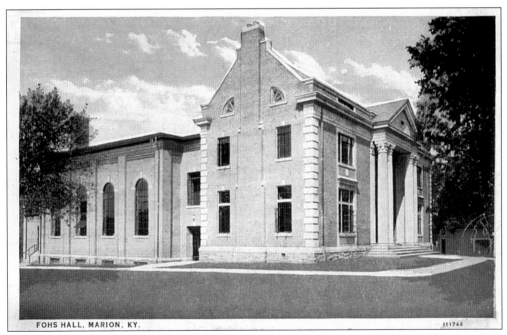

FOHS HALL, MARION, KY.

FOHS HALL, MARION. Fohs Hall was constructed opposite Marion High School and housed science laboratories, a gym, and an auditorium for use by the local high school students. The land and all construction costs were donated by Julius Fohs. Born in New York State, Fohs moved to Marion at a young age, graduated from Marion High School, and became a prominent geologist.

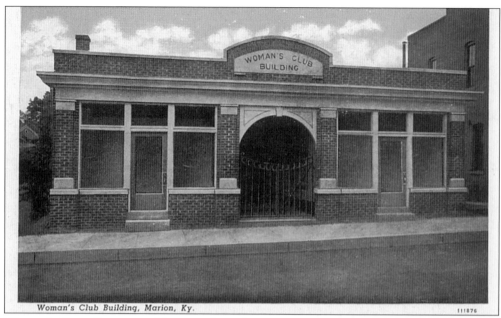

Woman's Club Building, Marion, Ky.

WOMAN'S CLUB BUILDING, MARION. Over the years, numerous social and fraternal buildings have been built throughout western Kentucky. Seen here is the Woman's Club Building in Marion. With its iron gate that leads into a dark corridor, the design of this building is a bit different from the design of most woman's club buildings.

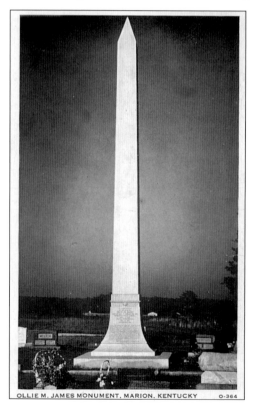

OLLIE M. JAMES MONUMENT, MARION, KENTUCKY O-364

OLLIE M. JAMES MONUMENT, MARION. One of the most prominent politicians in western Kentucky during the early 1900s was Ollie Murray James. He served in the United States House of Representatives between 1903 and 1913, then was elected to the United States Senate. Following his death in 1918, James was buried in Marion's Maple View Cemetery, where his grave is marked with this monument.

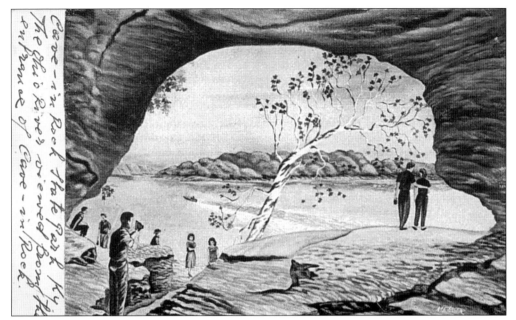

CAVE-IN-ROCK STATE PARK. During the late 1700s and early 1800s, travelers on the Ohio River were frequently victimized by a gang of pirates operating from a cave on the Illinois side of the river. Known simply as Cave-In-Rock, the small cave is now part of an Illinois state park. Visitors to the cave can get an impressive view of the Ohio River with Kentucky on the opposite banks.

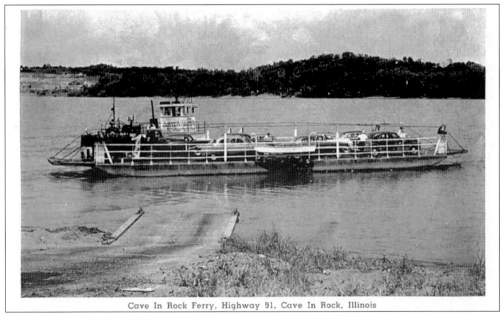

Cave In Rock Ferry, Highway 91, Cave In Rock, Illinois

CAVE-IN-ROCK FERRY, OHIO RIVER. By the 1830s most of the river pirates around Cave-In-Rock had been driven from the area and several small towns began to prosper, especially on the Kentucky side of the river. To connect these towns, a ferry was established across the Ohio River at Cave-In-Rock. It is still in service and is the last ferry operating across the Ohio River in western Kentucky.

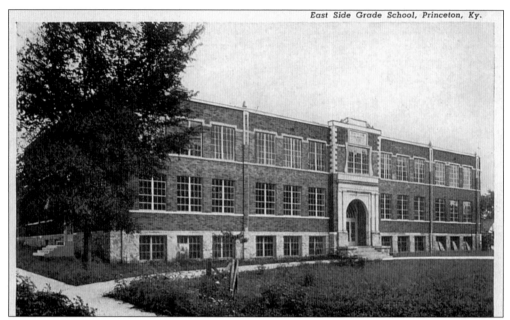

EAST SIDE GRADE SCHOOL, PRINCETON. In 1929, the building seen here was constructed to replace an older building destroyed by fire. Used as an elementary school until the 1980s, it has since been replaced by a newer building.

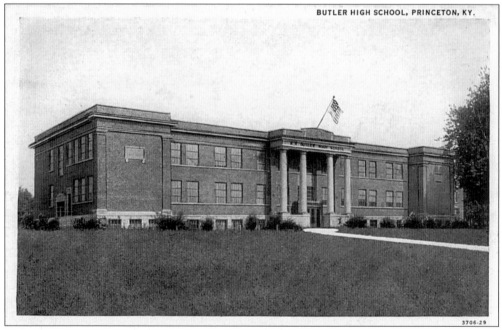

BUTLER HIGH SCHOOL, PRINCETON. This magnificent brick structure was built in 1923 and renamed Caldwell County High School in 1954 after the consolidation of city and county schools. In 1972, the high school students moved to a new building, and between 1972 and 1992, the building was used as a middle school. Today the building houses the central offices for the county school system.

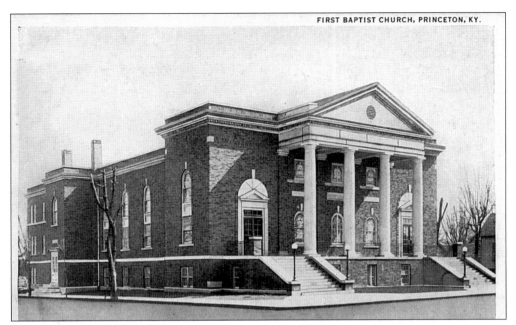

FIRST BAPTIST CHURCH, PRINCETON. After a fire in 1893 destroyed its original building, the congregation of the First Baptist Church in Princeton constructed a new building at the corner of Cave and Main Streets. The church was organized March 30, 1850, and is one of the oldest congregations in Princeton.

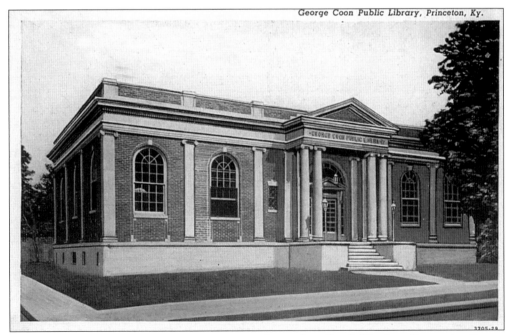

George Coon Public Library, Princeton, Ky.

GEORGE COON PUBLIC LIBRARY, PRINCETON. Located on South Harrison Street, the George Coon Public Library is named for a Princeton native who donated money and land during the library's construction. The library was built on land that had been the site of Coon's family home. Opened in April 1929, the library is still housed in this building.

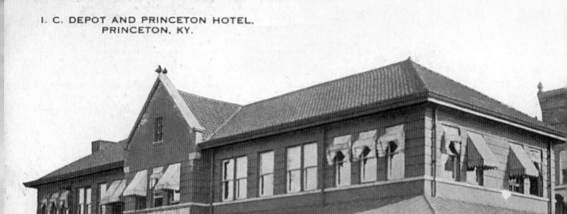

I. C. DEPOT AND PRINCETON HOTEL.
PRINCETON, KY.

ILLINOIS CENTRAL RAILROAD DEPOT, PRINCETON. The ICRR operated in all four directions from Princeton, with tracks leading to Hopkinsville, Paducah, Louisville, and Henderson. In 1916, at least 16 passenger trains stopped daily at this sprawling two-story depot to load and unload passengers. Several freight trains also passed through town daily, and the depot housed train dispatchers that controlled train movements throughout the area. A large percentage of the freight passing through Princeton was coal from the numerous coal mines surrounding Princeton. Locomotives were repaired and maintained at a roundhouse near downtown. Sadly, the depot is long gone and not as many trains pass through Princeton. The tracks south to Hopkinsville were ripped up in the late 1980s, and trains run north from Princeton only to Fredonia, a distance of about 13 miles. The tracks running east and west through town were purchased in 1986 by the Paducah and Louisville Railway, which maintains regular freight service on the line. Princeton's railroad heritage is remembered at a museum near downtown.

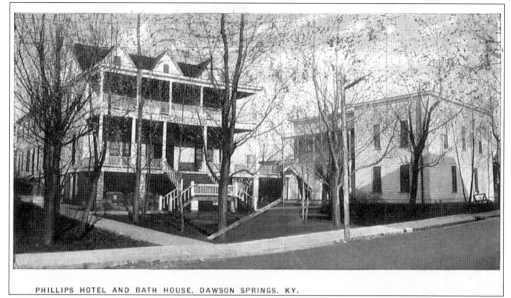

PHILLIPS HOTEL AND BATH HOUSE, DAWSON SPRINGS, KY.

PHILLIPS HOTEL AND BATH HOUSE, DAWSON SPRINGS. During the late 1800s and early 1900s, Dawson Springs was famous for its mineral springs that were believed to cure many diseases. The back of this card has the following handwritten message from the sender to her sick friend: "If you could be here awhile I believe you would be well. Such a good place to rest and such good water to drink."

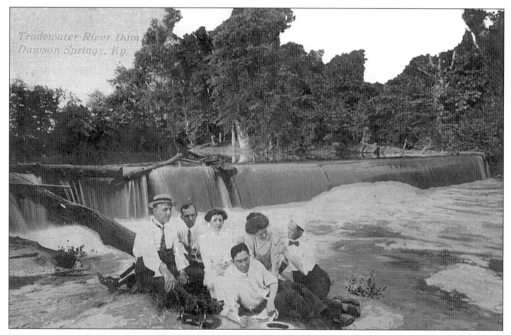

TRADEWATER RIVER DAM, DAWSON SPRINGS. For many years, the Tradewater River, which flows through Dawson Springs, has been a popular spot for socializing and recreation. One particular spot has been the "old Mill Dam." Today, the Tradewater River is but a shallow stream in many spots, but at one time it was deep enough to allow navigation by small excursion boats.

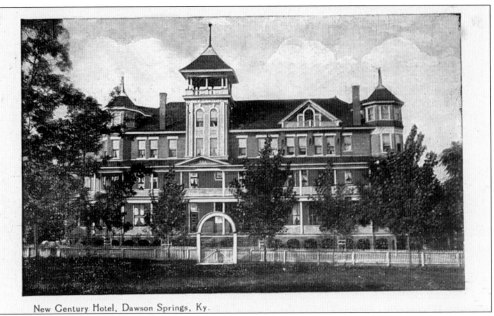

New Century Hotel, Dawson Springs, Ky.

NEW CENTURY HOTEL IN DAWSON SPRINGS. Approximately three dozen resorts and boarding houses were constructed by companies eager to exploit the healing powers of the local mineral waters. The "granddaddy" of these was clearly the New Century Hotel, built in 1902 and seen in this postcard mailed in 1908. The hotel hosted spring training for the Pittsburgh Pirates in 1914–1915 and was expanded with money provided by the baseball team.

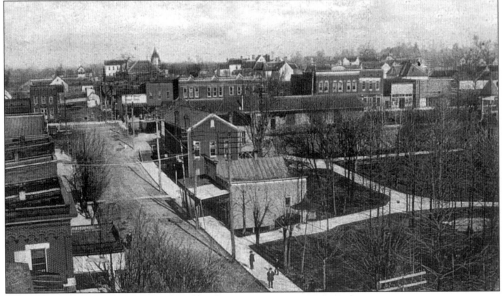

LOOKING NORTH FROM NEW CENTURY HOTEL TOWER, DAWSON SPRINGS. The tower of the New Century Hotel provided a commanding view of Dawson Springs. Barely visible in the center is the ICRR's depot, where thousands of persons disembarked in hopes of being cured by the local waters. Several of the resorts were located right along the tracks and were served directly by the trains.

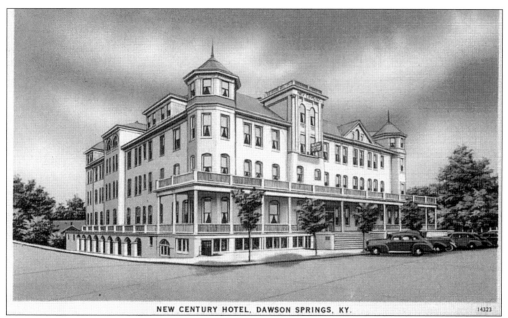

NEW CENTURY HOTEL, DAWSON SPRINGS, KY. 14323

NEW CENTURY HOTEL, DAWSON SPRINGS. This card from *c.* 1940 illustrates several modifications made to the New Century over the years. The tower, second-floor balcony, and much of the ornamental woodwork were removed and the front yard gave way to a street. Sadly, none of the many hotels and resorts that once were located in Dawson Springs still exist.

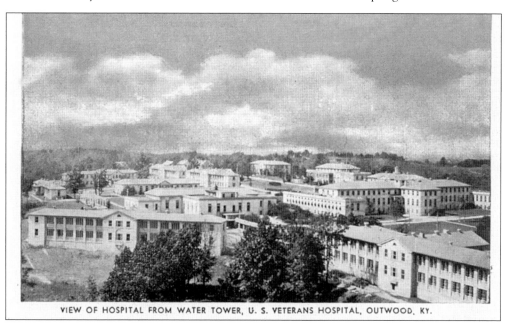

VIEW OF HOSPITAL FROM WATER TOWER, U. S. VETERANS HOSPITAL, OUTWOOD, KY.

VIEW OF UNITED STATES VETERAN'S HOSPITAL FROM WATER TOWER, OUTWOOD (DAWSON SPRINGS). On February 22, 1922, dedication ceremonies were held for a new veteran's hospital located three miles south of Dawson Springs. The hospital, consisting of 27 separate buildings, closed in July 1962. Afterwards, the land and buildings were given to the state of Kentucky for a hospital for the mentally handicapped.

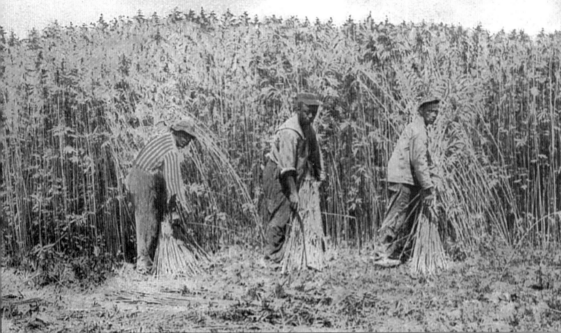

Hemp Cutting in Old Kentucky.

HEMP CUTTING. Though its production is now strictly forbidden, at one time it was quite common to find hemp plants growing on farms throughout western Kentucky. Early settlers in the region began growing hemp, a close cousin of the marijuana plant, in the early 1800s. The long fibers were used to make rope and a variety of heavy-duty fabrics that could be sold for a handsome profit. In the late 1800s, the hemp industry declined as rope manufacturers began using the Manila fiber. Many farmers then shifted from raising hemp to raising tobacco. With the outbreak of World War II and the disruption in supply of Manila fiber from the Philippines, Kentucky farmers raised hemp once again under strict government control. Today, Kentucky law has no provision for raising hemp even for industrial purposes, so it is a safe bet that raising this much hemp these days will attract the attention of law enforcement.

Six
KENTUCKY LAKE, BARKLEY LAKE, EDDYVILLE, KATTAWA

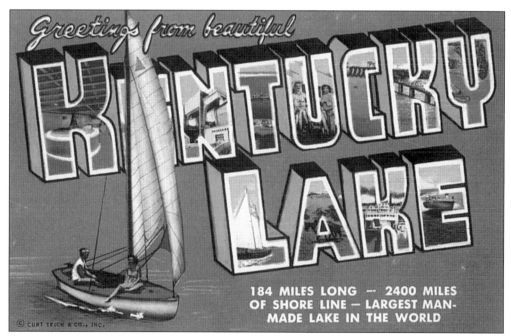

GREETINGS FROM KENTUCKY LAKE. After a series of disastrous floods during the early 1900s, the federal government decided to dam the Tennessee River approximately 20 miles east of Paducah. The dam was constructed under the direction of the newly formed Tennessee Valley Authority (TVA). When finished in 1944, Kentucky Dam and Kentucky Lake immediately became popular tourist destinations.

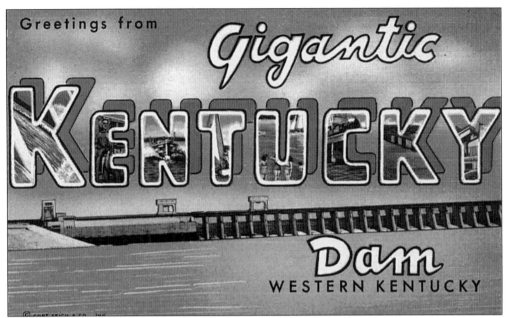

Greetings from *Gigantic* KENTUCKY *Dam*

WESTERN KENTUCKY

GREETINGS FROM GIGANTIC KENTUCKY DAM. Over the years, hundreds of colorful postcards have featured Kentucky Dam and Kentucky Lake, but few agree on the dimensions of the dam and its cost. The postcards featured in this chapter place the dam's width at either 8,412 or 8,650 feet, and the cost at either $108,000,000 or $114,000,000.

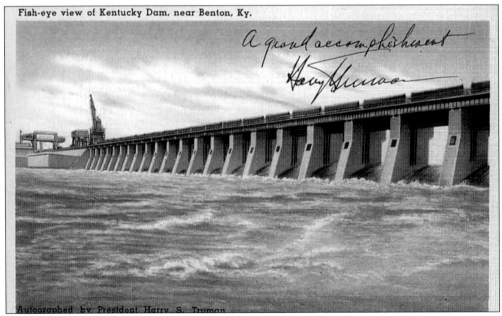

Fish-eye view of Kentucky Dam, near Benton, Ky.

A grand accomplishment

Harry Truman

Autographed by President Harry S. Truman

FISH-EYE VIEW OF KENTUCKY DAM. On October 10, 1945, Kentucky Dam was officially dedicated during a grand ceremony attended by President Harry S. Truman. Soon after, this postcard was released with a reproduction of Truman's signature and the message "A Grand Accomplishment." This view is from the west side of the dam looking towards the powerhouse and the lock.

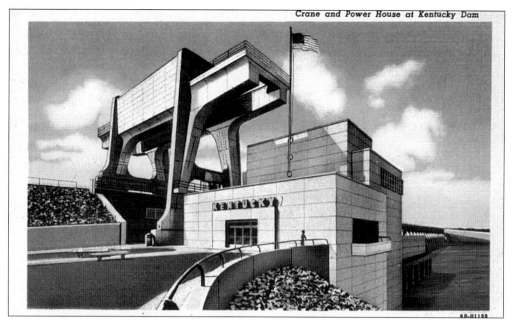

CRANE AND POWERHOUSE AT KENTUCKY DAM. The massive crane to the left of the flag is used to help maintain the four massive turbines inside the dam that generate electricity. Two smaller cranes travel across the dam to raise and lower the dam's floodgates.

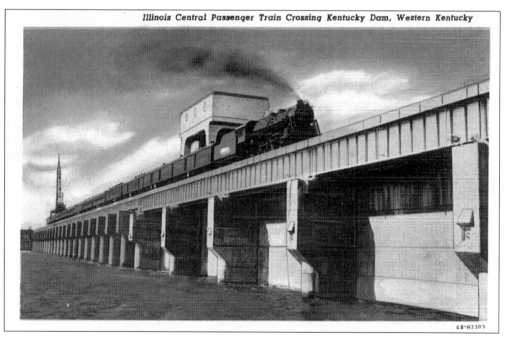

ILLINOIS CENTRAL RAILROAD PASSENGER TRAIN CROSSING KENTUCKY DAM. Construction of Kentucky Dam and nearby Barkley Dam forced the ICRR to relocate several miles of track along its Paducah-Louisville mainline. As compensation, the ICRR's tracks were laid across both dams. In this view, a passenger train from Paducah is rolling across the newly completed dam. US62 was relocated across the dam in 1947.

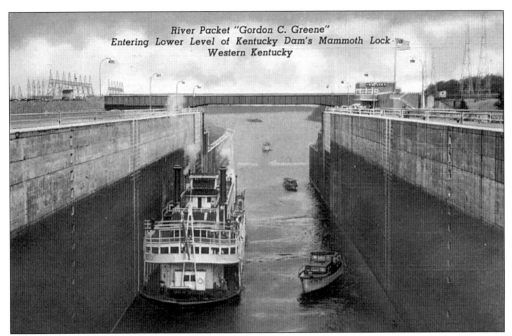

River Packet "Gordon C. Greene"
Entering Lower Level of Kentucky Dam's Mammoth Lock
Western Kentucky

BOATS NAVIGATING LOCK AT KENTUCKY DAM. These two cards show the excursion boat *Gordon C. Greene* and several small pleasure craft navigating the lock at Kentucky Dam. In the top view, the north gate is open and the boats are seen entering from the Tennessee River. The bottom view shows the same boats after the gate was closed and the lock was flooded. The boats have been lifted approximately 50 feet and will soon move out into Kentucky Lake once the south gate is opened. The passenger train in the background is en route from Paducah to Louisville.

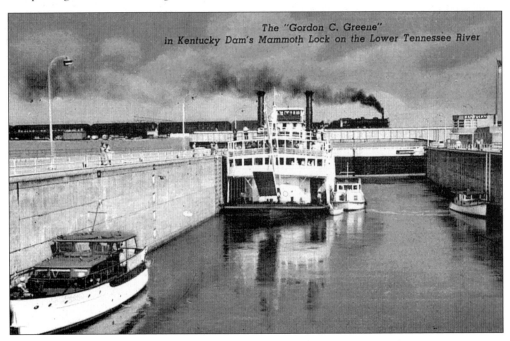

The "Gordon C. Greene"
in Kentucky Dam's Mammoth Lock on the Lower Tennessee River

AERIAL VIEW OF KENTUCKY DAM AND KENTUCKY LAKE. Only a very small portion of Kentucky Lake is visible in this aerial view. The lake backs up for 184 miles behind Kentucky Dam and has almost 2,200 miles of shoreline. Before the lake was flooded, countless homes, businesses, and cemeteries had to be relocated.

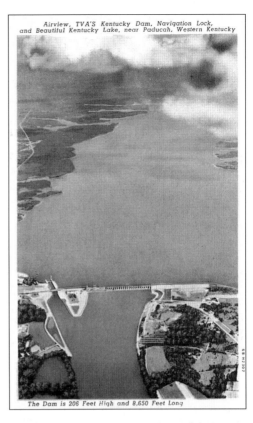

Airview, TVA'S Kentucky Dam, Navigation Lock, and Beautiful Kentucky Lake, near Paducah, Western Kentucky

The Dam is 206 Feet High and 8,650 Feet Long

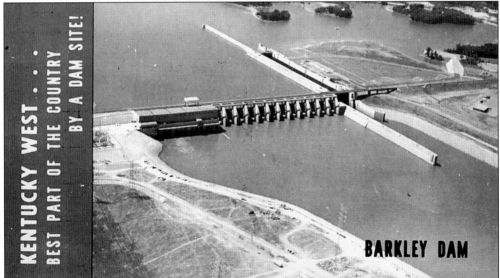

KENTUCKY WEST . . . BEST PART OF THE COUNTRY . . . BY A DAM SITE!

BARKLEY DAM

AERIAL VIEW OF BARKLEY DAM. Barkley Lake is visible in the upper portion of this card, which was published shortly after Barkley Dam was completed in 1965. The dam and lake are named after Alben W. Barkley, a Paducah native who served as United States Vice-President from 1949 to 1953. Barkley Dam and Kentucky Dam both have a set of railroad tracks across the top that are used daily, but only Kentucky Dam also has a highway on top.

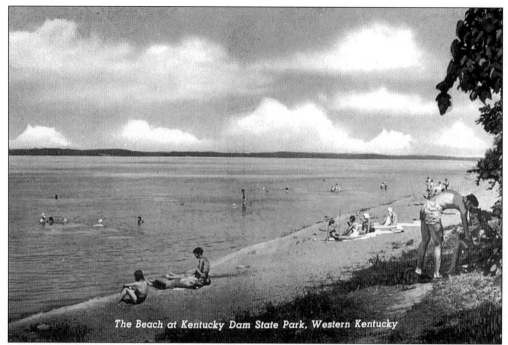

The Beach at Kentucky Dam State Park, Western Kentucky

BEACH AT KENTUCKY DAM VILLAGE STATE PARK, GILBERTSVILLE. Only a few hundred yards from Kentucky Dam is Kentucky Dam Village State Park. Thanks to its marina, golf course, lodge, and cabins, Kentucky Dam Village is one of the busiest state parks in Kentucky. The beach has been reconfigured since this postcard was published and is visible to motorists crossing Kentucky Dam.

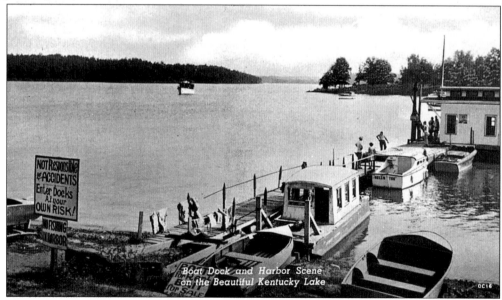

Boat Dock and Harbor Scene on the Beautiful Kentucky Lake

BOAT DOCK ON KENTUCKY LAKE. Pleasure cruisers, as well as commercial shippers, have benefited from the formation of Kentucky and Barkley Lakes. Numerous marinas and docks have been built on both lakes to cater to the local residents and tourists who want to go boating. The lakes also allow barges loaded with everything from coal to grain to move quickly and safely.

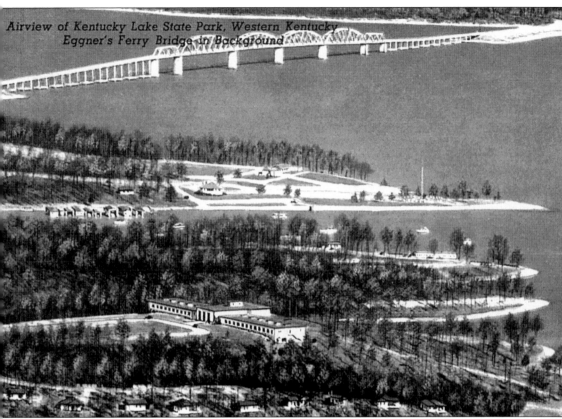

Airview of Kentucky Lake State Park, Western Kentucky
Eggner's Ferry Bridge in Background

AERIAL VIEW OF KEN LAKE STATE PARK, AURORA. Along with numerous private resorts, two state parks have been constructed along Kentucky Lake. Kentucky Dam Village literally sits next to the dam, while Ken Lake State Park is about 40 miles south of the dam. This aerial view shows the main resort building in the center, surrounded by several cottages. Several festivals are held at Ken Lake each year, with perhaps the best known being the Hot August Blues and Barbeque Festival. This festival combines great blues music with lots of delicious barbeque cooking and attracts musicians and spectators from several states The music performances are held at the park's lakeside amphitheater, and it is common to find dozens of boats anchored just off shore during the shows. The bridge in the background carries US68 and KY80 across the lake. Built in the 1930s, it had to be raised when Kentucky Lake was formed. It is due to be replaced around 2008 by a new four-lane bridge.

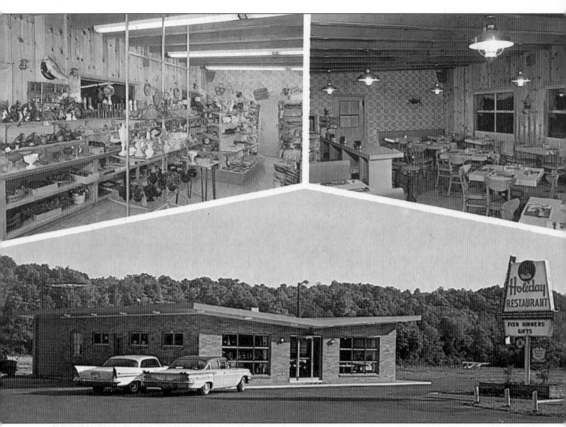

HOLIDAY RESTAURANT AND GIFTS, FENTON. During the mid-1960s, the narrow peninsula separating Kentucky and Barkley Lakes was seized by the United States government and turned into the Land between the Lakes recreation area. This required the relocation of all people living in an area covering approximately 170,000 acres and the relocation or demolition of every building in this area. Several of the residents had been relocated only a few years earlier from the lowlands flooded by Kentucky or Barkley Lakes, and were forced to move again. Several towns disappeared, leaving not a trace behind. One business forced out was Holiday Restaurant and Gifts at Fenton, less than a mile from Ken Lake State Park (see previous page). The advertisement on the back of this card says: "located 1500' East of the Fabulous Ky. Lake on U.S. Hiway 68. Ultra-Modern—Air Conditioned For Your Comfort. Specialize in Steaks—Chops—Famous Cat-Fish Dinners. Gift Shop—Souvenirs. If You Like Southern Hospitality and Good Food—Stop With Us." Unfortunately, not even this shop escaped the wrecking ball.

KUTTAWA MINERAL SPRING, KUTTAWA. The caption on the back of this card reads, "Kuttawa Mineral Springs is the playground of Western Kentucky. Fish, Swim, Ride, Relax, do anything you want for fun at Kuttawa Mineral Springs. Beautiful scenery adorns the landscape and the Springs will furnish the most invigorating water you ever tasted." Most of Kuttawa was flooded in the mid-1960s when the Cumberland River was dammed to form Barkley Lake.

STRINGER OF CRAPPIE FROM KENTUCKY LAKE. These fellows probably wish that crappie fishing wasn't such a popular sport on Kentucky and Barkley Lakes. The lakes support a wide variety of fish that attract anglers from throughout the country. During the 1980s, stocks of some fish began to diminish due to over fishing, but strict new regulations have helped increase the size and number of fish.

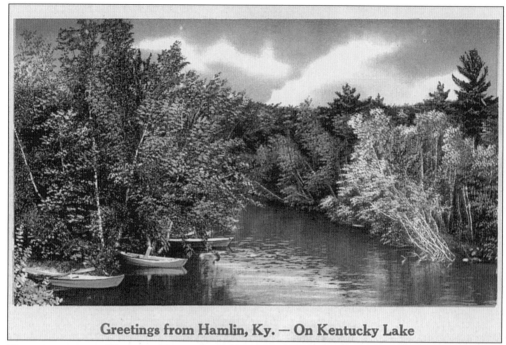

Greetings from Hamlin, Ky. — On Kentucky Lake

GREETINGS FROM HAMLIN, KENTUCKY. The small hamlet of Hamlin is located southeast of Murray on the western shore of Kentucky Lake. This particular card shows a generic lakeside scene rather than an actual location around Hamlin.

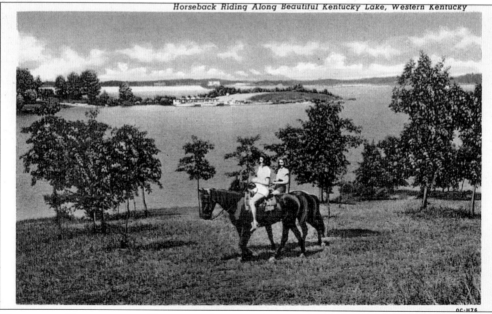

Horseback Riding Along Beautiful Kentucky Lake, Western Kentucky

HORSEBACK RIDING ALONG KENTUCKY LAKE. With the creation of Kentucky and Barkley Lakes and the Land between the Lakes recreation area, the tourism industry took off in western Kentucky. Numerous hiking, biking, and horseback riding trails have been established around the banks and provide excellent views of the lake.

70

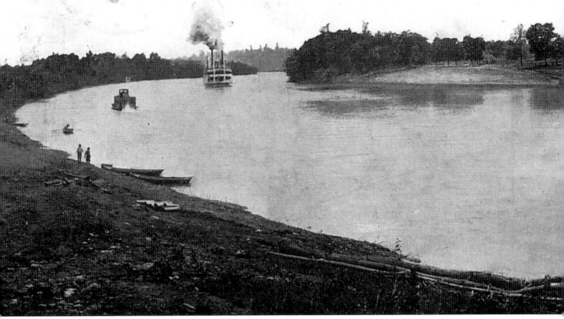

11902

FERRY ON THE OLD SUWANEE, LOOKING EASTWARD,
EDDYVILLE, KY.

RIVER FERRY, EDDYVILLE. The caption for this card says, "Ferry on the Old Suwanee, Looking Eastward, Eddyville," but it is actually the Cumberland River. To prevent a recurrence of the devastating floods that routinely struck western Kentucky in the mid-1900s, the Cumberland River was dammed in the mid-1960s to create Barkley Lake. About half the town of Eddyville was flooded in the process.

Kentucky Branch Penitentiary,
Eddyville, Ky.

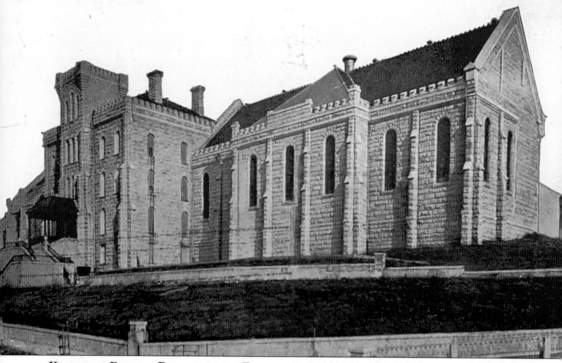

KENTUCKY BRANCH PENITENTIARY, EDDYVILLE. In 1884, the sleepy little town of Eddyville was selected as the site for a new prison. The new prison was named the "Kentucky Branch Penitentiary" because the prison supplemented the main state prison in Frankfort. Construction took six years and cost approximately $420,000. Much of the stone was quarried near the town of Paradise (see page 30), approximately 100 miles to the east, and carried by river barges to the prison. The prison officially opened on Christmas Eve 1890 and was promptly dubbed the "Castle on the Cumberland" due to its elegant appearance and close proximity to the Cumberland River. Despite its nickname, the prison has always been anything but a place for fun. In 1911, the first of 164 executions was carried out at the Eddyville prison. Seven prisoners were executed early on the morning of July 13, 1929. In 1912, the Eddyville prison was renamed the Kentucky State Penitentiary and remains the state's only maximum security prison.

Seven

MURRAY
and MAYFIELD

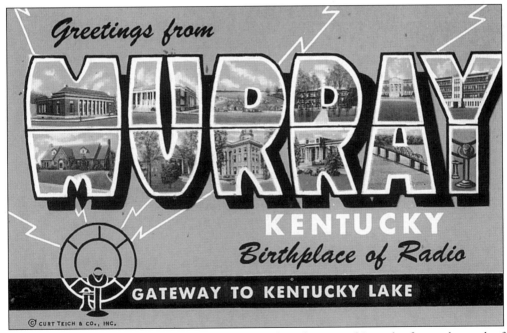

GREETINGS FROM MURRAY. The "Birthplace of Radio" slogan on this card refers to the work of Nathan B. Stubblefield, an eccentric local inventor. During the 1890s and early 1900s, Stubblefield invented a method of transmitting messages through the ground and water. Stubblefield's invention was revolutionary, but was not technically "radio." Yet, for many years local citizens have promoted Stubblefield as the inventor of radio.

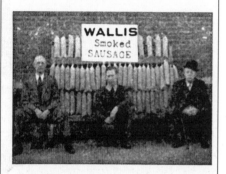

Wallis' Smoked Sausage

Cured the "Old Time" Way
With Hickory Fire Smoke

WALLIS
Smoked
SAUSAGE

PACKED IN 2lb and 3lb Bags

Per Pound F. O. B. Murray, Ky.

J. T. WALLIS & SON
P. O. Box 387 Murray, Kentucky

WALLIS'S SMOKED SAUSAGE, MURRAY. Using the mail to send advertising messages is certainly not a recent development, as witnessed by this undated postage for Wallis's Smoked Sausage. The card boasts that the sausage is "Cured the 'Old Time' Way with Hickory Fire Smoke" and is available in two- or three-pound bags.

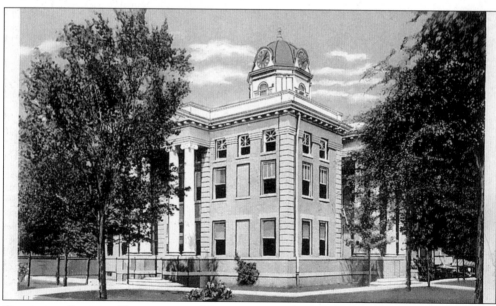

CALLOWAY COUNTY COURTHOUSE, MURRAY. Created in 1821 from a portion of Hickman County, Calloway County was the 72nd of Kentucky's 120 counties to be formed. The present courthouse was fourth to be constructed and cost approximately $50,000 to build in 1913. Several county offices are still housed inside, but the judicial courts have relocated elsewhere in town.

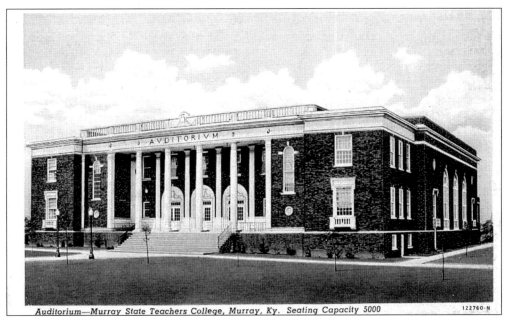

Auditorium—Murray State Teachers College, Murray, Ky. Seating Capacity 5000 122760-N

LOVETT AUDITORIUM, MURRAY STATE TEACHERS' COLLEGE. Murray State University (MSU) was originally known as Murray State Teacher's College and then Murray State College before gaining its present name in 1966. The sixth building constructed on campus was the auditorium, which cost $176,000 and was completed in January 1928. Basketball games were held inside until Carr Health Building opened in 1937.

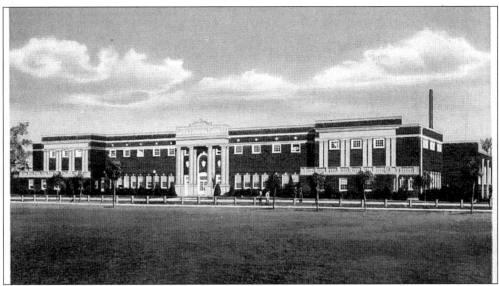

CARR HEALTH BUILDING, MURRAY STATE TEACHERS' COLLEGE. Carr Health Building cost $240,000 and, in its original configuration, housed two basketball courts, eight handball courts, a boxing ring, and a swimming pool. In the mid-1950s, basketball games moved into Racer Arena, which was built onto the rear of the building. The noise in Racer Arena was usually quite intense during games, and few visiting teams ever won there. In 1999 basketball games were moved to a new arena across campus.

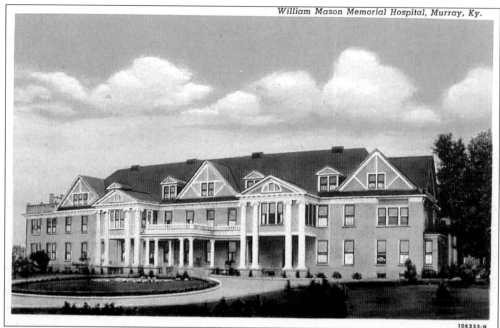

William Mason Memorial Hospital, Murray, Ky.

106333-N

WILLIAM MASON MEMORIAL HOSPITAL, MURRAY. In April 1921, William Mason Memorial Hospital opened on Poplar Street in Murray. The hospital was founded by brothers William Herbert Mason and Robert Macon Mason. They named the hospital in honor of their father and grandfather, who were both named William Mason. This hospital replaced the old Murray Surgical Hospital, which was founded in August 1910 by William Herbert Mason and was located on South Fourth Street.

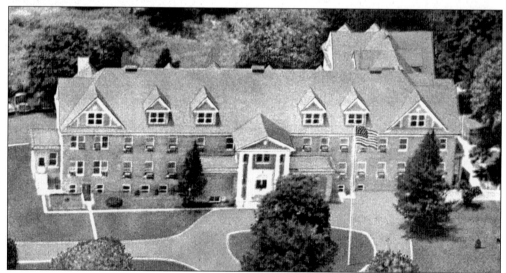

MURRAY HOSPITAL, MURRAY. On the night of February 17, 1935, a fire destroyed the hospital at the top of the page. Fortunately, no lives were lost—thanks to the bravery of the nurses and a maintenance man. A new hospital, similar in appearance to the old one and shown at the bottom of the page, was constructed on the site. The new building was completed in July 1936 and had 154 beds.

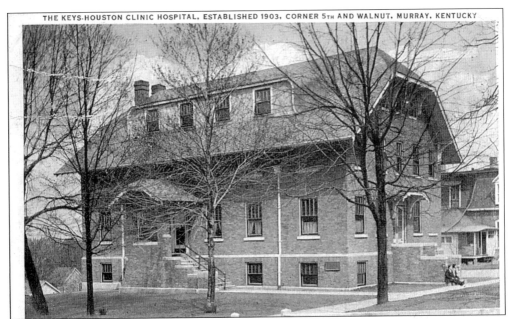

KEYS-HOUSTON CLINIC HOSPITAL, MURRAY. On April 30, 1942, Mason Memorial Hospital merged with the Keys-Houston Clinic to form the Murray Hospital Association, which was owned by the city of Murray. Previously, both the hospital and clinic were privately owned with no public support. The Keys-Houston Clinic was then closed and the Mason Memorial Hospital was renamed Murray Hospital.

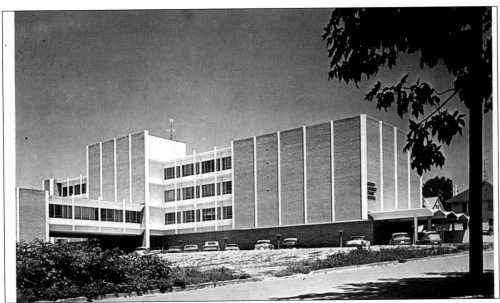

MURRAY-CALLOWAY COUNTY HOSPITAL, MURRAY. In 1964, the Calloway County government acquired half ownership of the local hospital, which was renamed Murray-Calloway County Hospital. That same year a new hospital was built next to the old one, which was turned into a convalescent care unit. The building seen here has been enlarged several times and the old hospital was demolished in 1979.

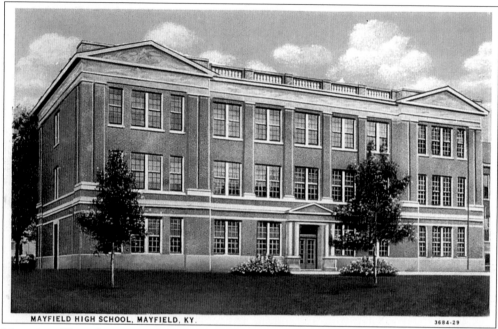

MAYFIELD HIGH SCHOOL, MAYFIELD, KY. 3684-29

MAYFIELD HIGH SCHOOL, MAYFIELD. In 1886, the West Kentucky College was established in Mayfield along Walnut Street to educate the children of Mayfield's wealthier citizens. Around 1908 the college closed and the Mayfield High School building seen here was built on the site. In 1973, a new high school opened on Douthitt Street and this building was demolished.

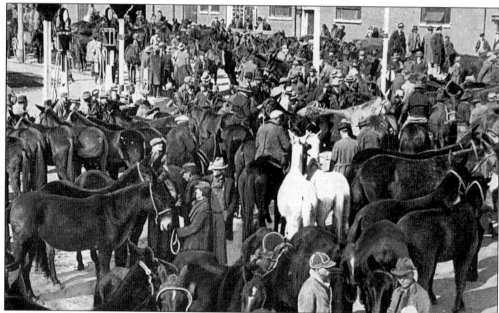

MULE DAY, MAYFIELD. The third Monday of each month was known in Mayfield as Trade Day, when folks gathered around the courthouse square to buy, sell, or trade nearly anything of value. Up until the mid-1900s, Trade Day in March was Mule Day, when the square was flooded with dozens of mules for sale. Mule Day is now a memory but Trade Day continues at the fairgrounds.

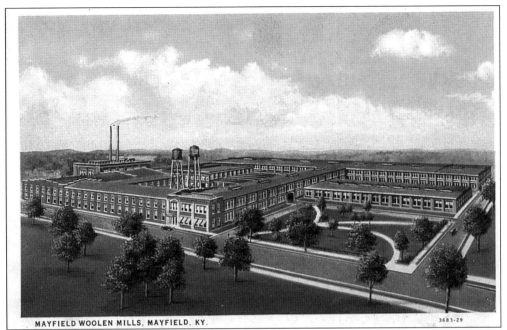

MAYFIELD WOOLEN MILLS, MAYFIELD, KY. 3683-29

MAYFIELD WOOLEN MILLS, MAYFIELD. During the late 1800s and early 1900s, three different textile plants were constructed in Mayfield. The oldest of the mills was the Mayfield Woolen Mills, established in 1859. Local legend has it that the mill made blankets for both the United Sates and Confederate armies during the Civil War. After several changes in ownership, the mill closed in 1994 and burned in September 1996.

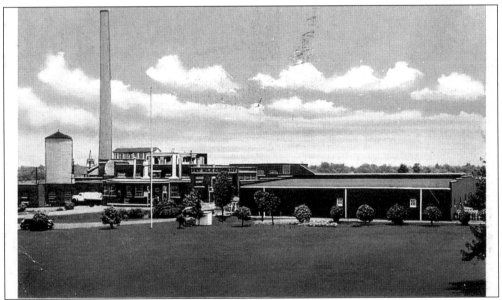

PET MILK CO., MAYFIELD. In 1928, the Pet Milk Co. opened this plant on the north side of Mayfield to produce condensed milk. The plant's arrival prompted dozens of farmers in the region to start raising dairy cows. After closing several years ago, the building has housed a variety of businesses and been heavily modified with the addition of numerous doors and windows.

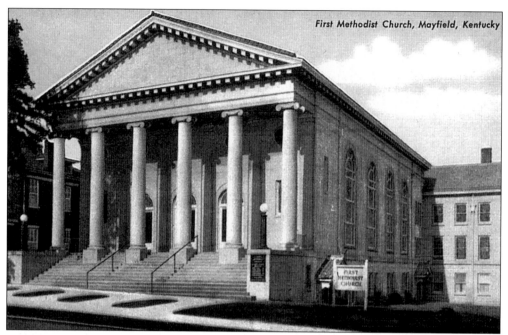

First Methodist Church, Mayfield, Kentucky

FIRST METHODIST CHURCH, MAYFIELD. Organized around 1837, the First United Methodist Church in Mayfield occupied four different buildings before moving in 1920 to its present location at the corner of Water and Eighth Streets. The current building cost approximately $100,000. Construction began in summer 1917, was suspended in summer 1919 due to a wartime shortage of steel, resumed in early 1919, and was completed in late 1920.

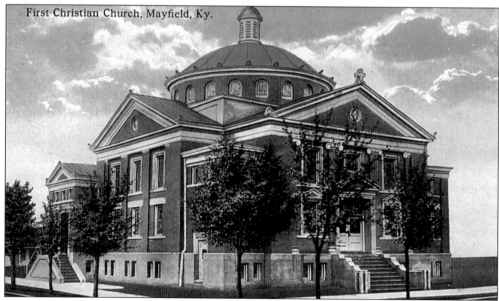

First Christian Church, Mayfield, Ky.

FIRST CHRISTIAN CHURCH, MAYFIELD. After organizing in 1853, the congregation of the First Christian constructed a simple brick building near downtown Mayfield. In early 1908 that building was replaced by the building seen here, which is still in use. Located at Ninth and South Streets, the church has been expanded several times over the years.

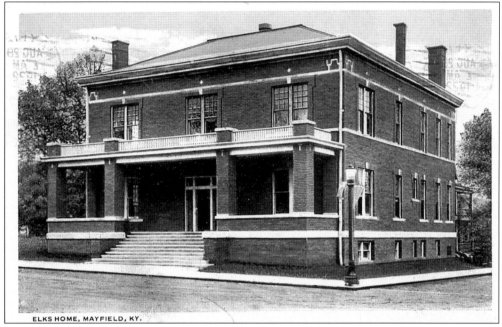

ELK'S HOME, MAYFIELD. Organized in Mayfield on July 12, 1902, the Elk's Club built this magnificent house at the corner of North Seventh and North Streets in 1902. From its earliest days, the club's benevolent activities have garnered the club a considerable amount of attention. A 1922 history book noted that the club donated an average of $450 each year to the city's poor.

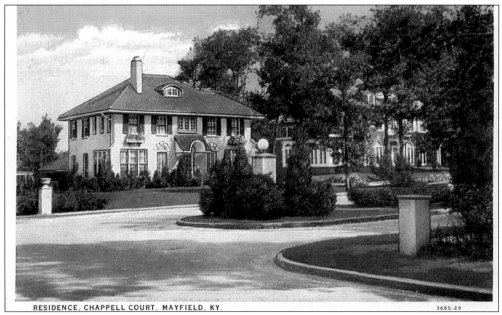

CHAPPELL COURT RESIDENCE, MAYFIELD. Prosperous manufacturing and agricultural industries during the late 1800s and early 1900s provided many residents of Mayfield with the money to build grand houses. Many of these residences retain their original elegance, with several prime examples on Chappell Court.

81

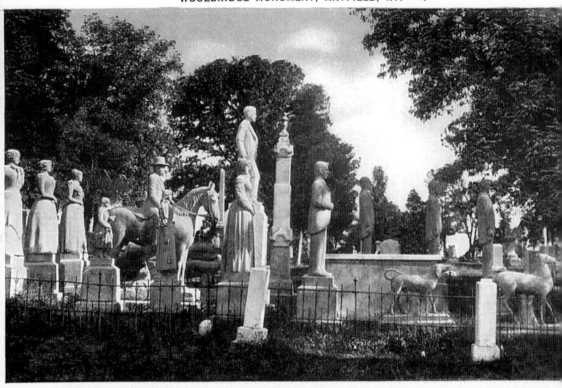

WOOLDRIDGE MONUMENT, MAYFIELD. The Wooldridge Monument in Mayfield's Maplewood Cemetery has often been called the "The Strange Procession That Never Moves." In 1893, Col. Henry Wooldridge commissioned a statue of himself carved from Italian marble. The statue was placed at Wooldridge's grave following his death in 1899 and was joined by 17 other stone carvings of a fox, a horse, two hounds, a deer, and several family members.

Eight

PADUCAH

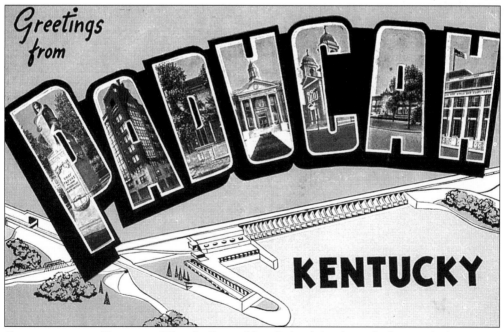

GREETINGS FROM PADUCAH. Historically speaking, Paducah has been the largest city in western Kentucky. Both Henderson and Hopkinsville now have more residents than Paducah according to the 2000 census. Nevertheless, there can be no denying that Paducah has had a very colorful and interesting history, as illustrated by the postcards in this chapter.

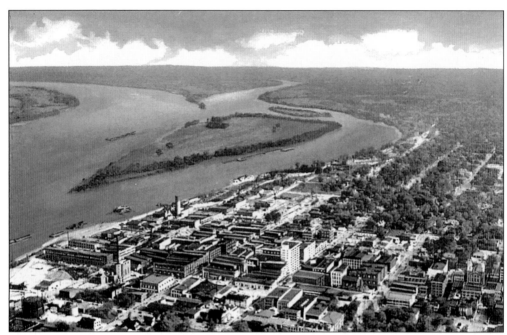

AERIAL VIEW OF PADUCAH. Located at the junction of the Ohio and Tennessee Rivers, Paducah was originally called Pekin. The name change took place when Paducah was officially chartered as a town on January 11, 1830. In this view, the Ohio River is seen flowing in from the left while the Tennessee River flows in from the right.

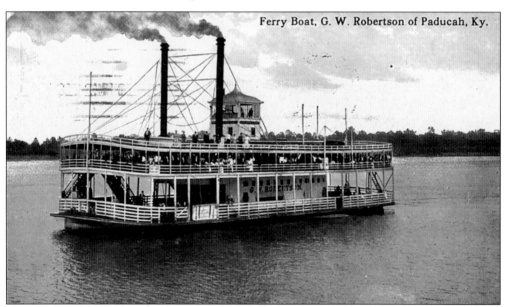

Ferry Boat, G. W. Robertson of Paducah, Ky.

FERRY BOAT *G.W. ROBERTSON,* PADUCAH. Over the years, several boats were based at Paducah to ferry pedestrians, motor vehicles, and even railroad cars across the Ohio River. The railroad ferries were replaced in 1918 by a bridge at Metropolis, Illinois, while the pedestrian and vehicle ferries remained active until 1929 when the Irvin Cobb bridge opened between Paducah and Brookport, Illinois.

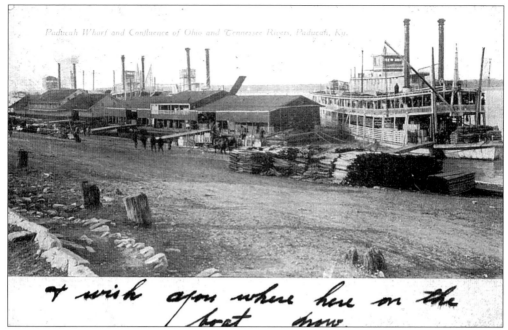

Paducah Wharf and Confluence of Ohio and Tennessee Rivers, Paducah, Ky.

I wish you where here on the boat now.

PADUCAH WHARF. Because of its location at the junction of the Ohio and Tennessee Rivers, Paducah evolved into an important shipping point for boats on both rivers. This card shows part of the extensive wharf that once existed in Paducah. The wharf is long gone, along with a large riverboat repair facility, but Paducah is still an important base for barge companies.

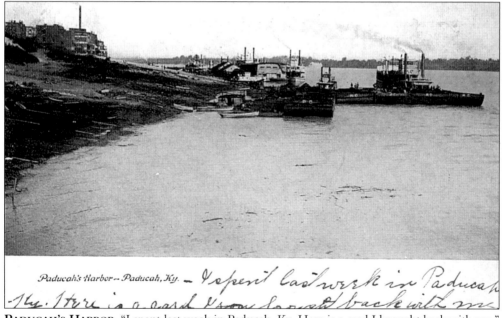

Paducah's Harbor—Paducah, Ky. — *I spent last week in Paducah Ky. Here is a card I brought back with me*

PADUCAH'S HARBOR. "I spent last week in Paducah, Ky. Here is a card I brought back with me," reads the handwriting at the bottom of this card. This card was postmarked January 3, 1908, from Olmstead, Illinois, about 20 miles downstream from Paducah. By this date, the river industry was moving away from the traditional paddleboat and towards the large barges that are seen today.

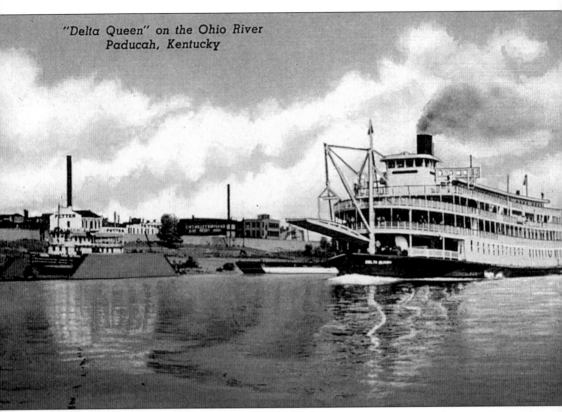

"Delta Queen" on the Ohio River
Paducah, Kentucky

DELTA QUEEN, PADUCAH. A handful of old paddleboats have been restored for excursion service and stop at Paducah each year. The most famous of these is the *Delta Queen*. The *Queen* and its twin, the *Delta King*, were built in 1927 for luxury overnight service between San Francisco and Sacramento, California. Built using elegant woods and the finest amenities, the boats cost an amazing $1 million each. The two boats cruised out of San Francisco and Sacramento until September 29, 1940. Afterwards, they were leased to the United States Navy for service around San Francisco. On December 17, 1946, the *Delta Queen* was sold for excursion service on the Mississippi and Ohio Rivers. The boat then made a long, slow journey from San Francisco, through the Panama Canal, and up to Pittsburgh for a thorough restoration. The *Delta Queen* made its first excursion on June 21, 1948, and has made numerous cruises since then. As for the *Delta King*, it survives as a floating restaurant in Sacramento, California.

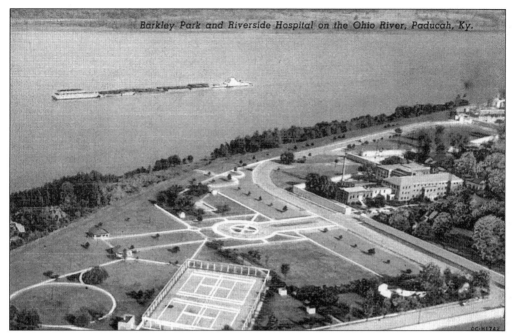

BARKLEY PARK AND RIVERSIDE HOSPITAL, PADUCAH. Barkley Park, along the Ohio River east of the downtown district, is one of several Paducah parks that today are just a memory. Named for Paducah native Alben W. Barkley, United States vice-president between 1949 and 1953, the park was created in the 1940s. During the mid-1980s, the park site was sold and redeveloped as J.R.'s Executive Inn.

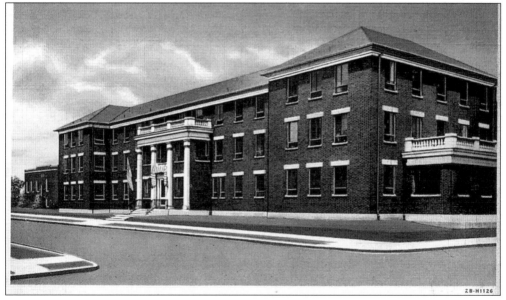

RIVERSIDE HOSPITAL, PADUCAH. In 1905, Riverside Hospital was built on the site of Fort Anderson, a Civil War fort built by Union troops. Originally owned by the city of Paducah, the hospital was sold in 1959 to the Catholic Church and renamed Lourdes. In 1973, Lourdes moved into a new building on Lone Oak Road and in 2001, the building seen here was demolished.

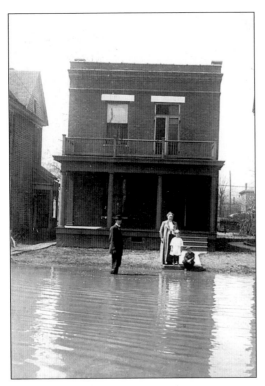

1913 OHIO RIVER FLOOD, PADUCAH. Over the years, Paducah and western Kentucky have been hit by several devastating floods on the Ohio and Tennessee Rivers. In this view, a family is standing in front of their house during the flood of 1913. Fortunately for them, the floodwaters appear to have stopped just short of their sidewalk, but others in town were not so lucky.

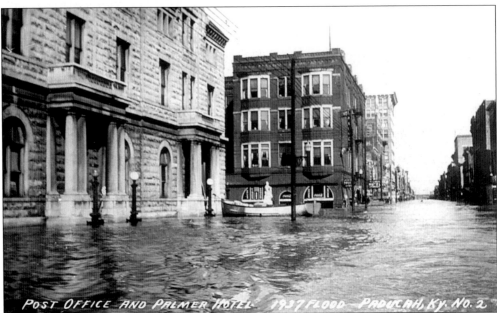

POST OFFICE AND PALMER HOTEL 1937 FLOOD PADUCAH, KY. NO. 2

DOWNTOWN PADUCAH, 1937 FLOOD. The "granddaddy" of all Paducah floods occurred in late January and early February 1937. Water stood six feet deep in the downtown business district and virtually all residents were forced to evacuate for over two weeks. This card shows the scene at Fifth and Broadway, looking east towards the Ohio River. The old post office is to the left, while a portion of the Palmer Hotel is visible in the center.

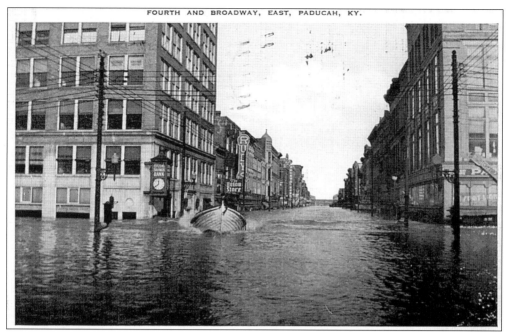

DOWNTOWN PADUCAH, 1937 FLOOD. A motorboat kicks up a strong wake as it zips through the intersection at Broadway and Third Street during the 1937 flood. At the height of the flood, water stood eight feet deep in the Citizens Bank building to the left. Paducah gained national fame with the publication of a photo showing a cow on the second floor porch of a house on North Sixth Street.

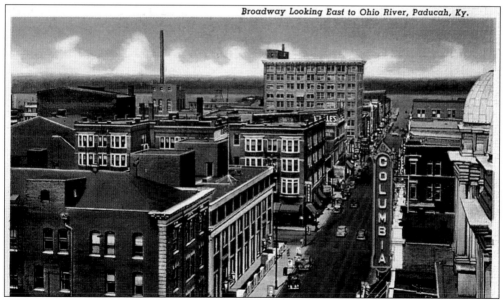

Broadway Looking East to Ohio River, Paducah, Ky.

BROADWAY LOOKING EAST TO OHIO RIVER, PADUCAH. In 1945, an eight-mile floodwall was built along the Ohio and Tennessee Rivers at Paducah to prevent further flooding. This bird's-eye view is from the corner of Broadway and Sixth Streets looking east to the Ohio River. Most of the buildings seen here are still standing with the exception of the Palmer Hotel, visible in the center.

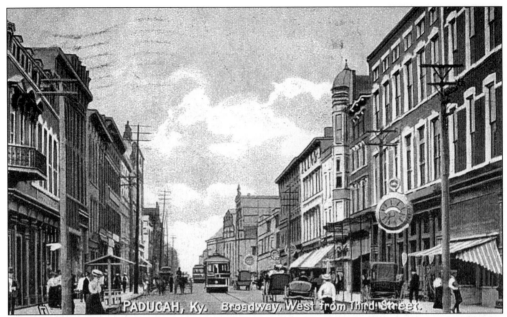

THIRD AND BROADWAY, PADUCAH. Postmarked in 1908, this card provides an intriguing view of downtown Paducah during the early 20th century. The view is looking west down Broadway, away from the Ohio River, at the intersection with Third Street. Not a single automobile can be seen among the streetcars and horse-drawn buggies. Streetcar service began in 1872 using mule-drawn cars and in 1890 electric streetcars entered service.

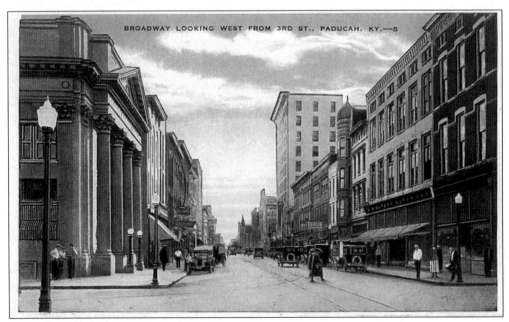

THIRD AND BROADWAY, PADUCAH. This card, dating from *c.* 1920, shows the same intersection looking in the same direction as the card at the top of the page. Several changes have occurred over the years. Electric poles have been removed from the sidewalk, the First National Bank building has been constructed to the left, and the City National Bank building stands in the distance.

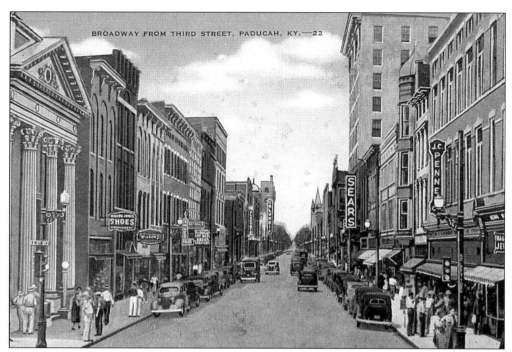

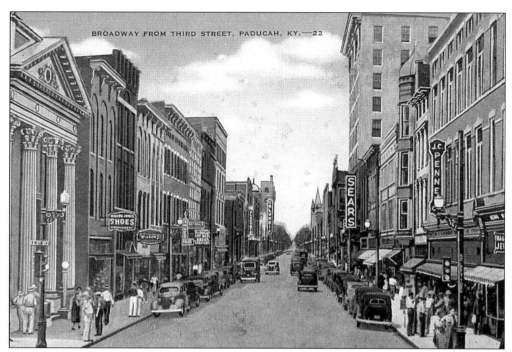

THIRD AND BROADWAY, PADUCAH.
Additional changes at the intersection of
Broadway and Third Streets can be seen in
this postcard from the late 1940s or early
1950s. Along with numerous locally owned
stores, Sears and J.C. Penney were located
along this section of Broadway. Within a few
years, J.C. Penney would relocate to a new
building at Fifth and Broadway built on the
site of the old Palmer Hotel.

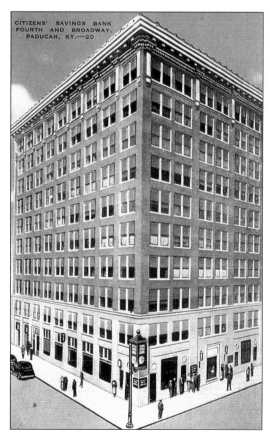

CITIZENS SAVINGS BANK, PADUCAH. In
1910, two of Paducah's largest banks
constructed new buildings in downtown
Paducah. The First National Bank building
at Broadway and Third Street stood three
stories tall. Not to be outdone, the City
National Bank constructed a ten-story
building at the corner of Broadway and
Fourth Streets. The bank's name has
changed several times, but this building
remains the tallest in downtown Paducah.

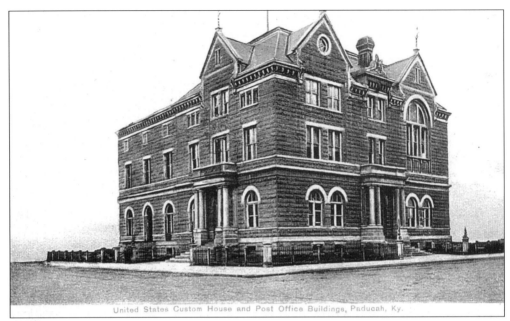

United States Custom House and Post Office Buildings, Paducah, Ky.

UNITED STATES CUSTOMHOUSE AND POST OFFICE, PADUCAH. Over the years, several grand public buildings have been constructed in Paducah. This three-story building was constructed in 1882 at the corner of Broadway and Fifth Streets to house the post office, custom house, and federal courts. After the 1937 flood, the building was demolished and the current post office and federal courthouse were built on the site.

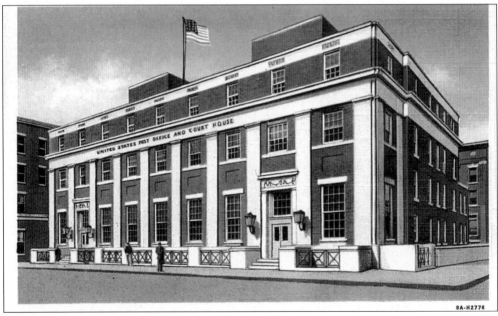

UNITED STATES POST OFFICE AND COURTHOUSE, PADUCAH. Seen here is the "new" post office and courthouse built in 1937 to replace the building at the top of the page. In the 1970s, the post office vacated this building in favor of a new building on South Fourth Street that is still in use. The building still houses various federal courts and offices.

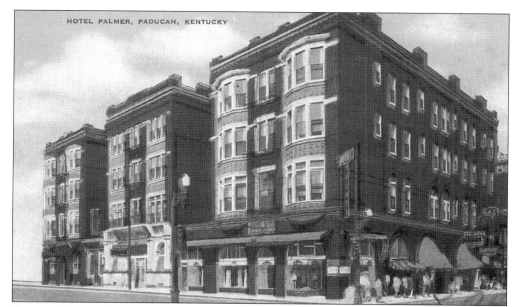

PALMER HOTEL, PADUCAH. In 1891–1892, the Palmer Hotel was built at Broadway and Fifth Streets directly across from the post office. The hotel cost approximately $170,000 to build and furnish. Interior lighting was initially provided by more than 600 gas jets rather than electric lights. One of the finest hotels in Paducah during its time, it was demolished in the late 1950s to make way for a J.C. Penney store.

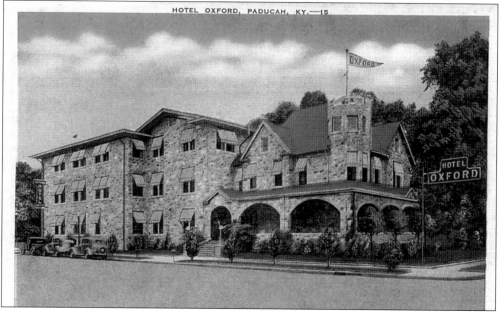

OXFORD HOTEL, PADUCAH. The Oxford Hotel stood at the corner of Jefferson and Fifth Streets, just a block north of the Palmer Hotel. With its stone construction, broad front porch, and window awnings, the Oxford Hotel was noticeably different from Paducah's other downtown hotels, the Palmer Hotel and Irvin Cobb Hotel. The hotel is now just a memory, and the site where it once stood is a parking lot.

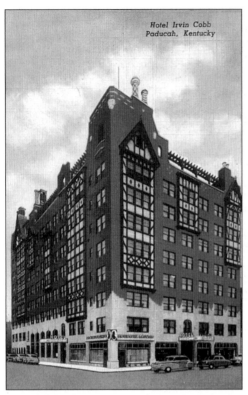

Hotel Irvin Cobb
Paducah, Kentucky

HOTEL IRVIN COBB, PADUCAH. The Hotel Irvin Cobb opened in 1929 at the corner of Sixth Street and Broadway. Costing nearly $400,000 to build, the hotel was named for Irvin Cobb, a Paducah native and famous humorist and writer. The eight-story hotel quickly became the social center of downtown Paducah. After closing in the 1970s the hotel was remodeled as an apartment building for senior citizens.

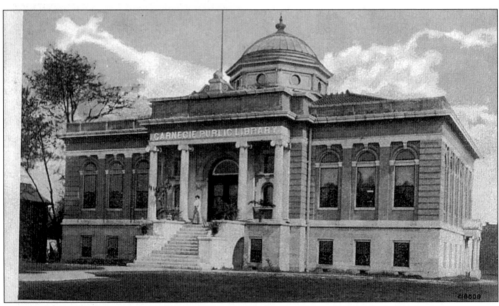

CARNEGIE PUBLIC LIBRARY, PADUCAH. As an illustration of the city's progressive nature, Paducah was one of the first cities in western Kentucky to open a Carnegie library. Located at Broadway and Ninth Streets, the library opened on October 4, 1904. After being damaged by fire in the mid-1960s, the library was demolished and replaced by the current library on Washington Street.

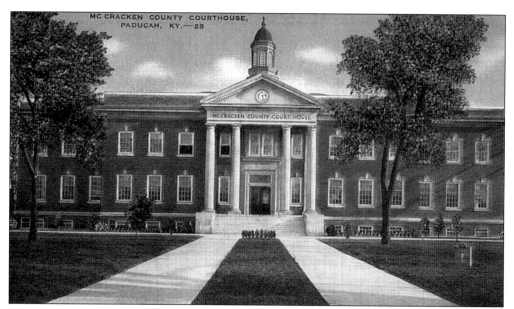

MCCRACKEN COUNTY COURTHOUSE, PADUCAH. Paducah is the county seat of McCracken County, formed in 1821 from Hickman County. The present courthouse, seen here, was built in 1941–1942 at a cost of $344,000. It replaced an older courthouse completed in 1861 at a cost of $27,830. The county's first courthouse was built in 1831 and was located on South Market Street, now called Second Street.

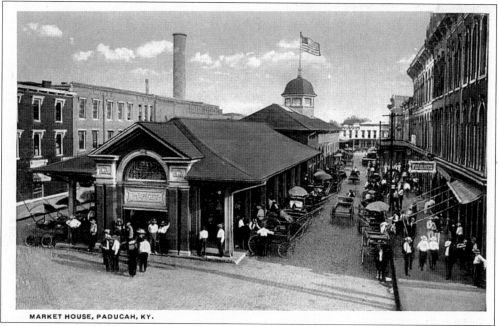

MARKET HOUSE, PADUCAH. Paducah's growth in its earliest days was fueled in part by the robust trade at its market house. The first market house in Paducah opened in 1836, while the current structure along lower Broadway near the Ohio River was built in 1905. The building closed as a market in the 1960s but has been redeveloped and now houses a museum, art gallery, and theater.

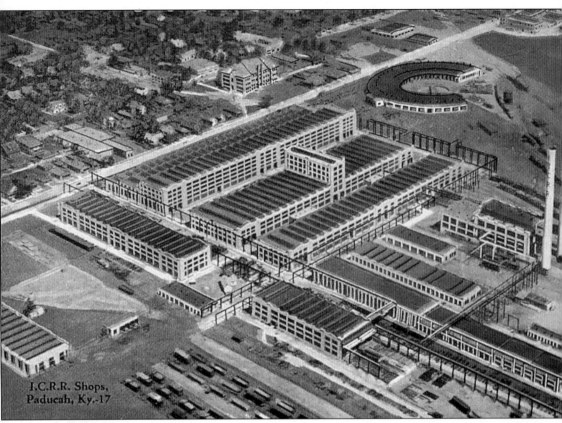

I.C.R.R. Shops,
Paducah, Ky.-17

ILLINOIS CENTRAL RAILROAD LOCOMOTIVE REPAIR SHOPS, PADUCAH. The Illinois Central Railroad's locomotive repair shops in Paducah are frequently proclaimed as the "world's largest shops." This is not accurate because other shops were larger. However, the shops certainly were a grand accomplishment. Located along Kentucky Avenue the shops took over two years to build between March 1925 and September 1927. The shop property covers 110 acres, with 21 acres under roof. Over 6.5 million bricks and 60,000 barrels of cement were used in the construction. Nearly $8.4 million was spent on the buildings and the machinery, plus another $3 million to buy the land and prepare it for construction. At its peak, the shops employed nearly 1,500 men. Employment fell rapidly during the 1950s as the ICRR switched to diesel locomotives, but the shops remained open. Between 1967 and 1982 over 700 diesel locomotives were rebuilt here for the ICRR (which was renamed Illinois Central Gulf Railroad in 1972). Nearly 300 more diesel locomotives were rebuilt under contract for railroads stretching from Alaska to Africa. In 1986, the shops were sold to VMV Enterprises, which continued to operate the shops until April 2, 2002, when they shut down due to business conditions. As this book goes to press, several companies are competing to buy the shops.

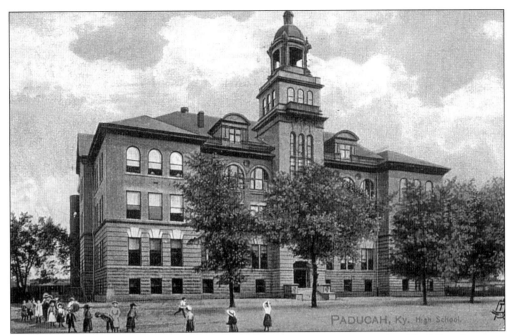

PADUCAH HIGH SCHOOL. Only memories remain of this magnificent school building that once stood along the 1200 block of Broadway. Built *c.*1900, it was originally known as Paducah High School. After a new high school building opened across town in 1921, the building became Washington Junior High School and has since been demolished.

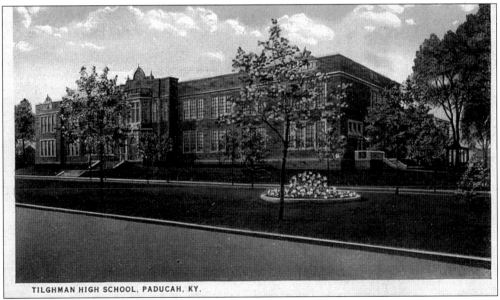

TILGHMAN HIGH SCHOOL, PADUCAH, KY.

PADUCAH TILGHMAN HIGH SCHOOL. This building replaced the one at the top of the page. The school has since moved to a new building. It was named after Lloyd Tilghman, a Paducah native and Confederate general who was killed during the Battle of Vicksburg, Mississippi, on May 16, 1863. Before joining the military, Tilghman was the chief engineer for the New Orleans and Ohio Railroad, the first railroad in Paducah.

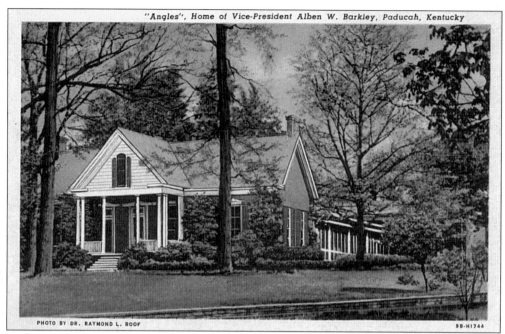

Angles", Home of Vice-President Alben W. Barkley, Paducah, Kentucky

PHOTO BY DR. RAYMOND L. ROOF

9B-H1744

"ANGLES," PADUCAH. Built in the mid-1800s, this was the home of Alben W. Barkley, United States vice-president between 1949 and 1953. Barkley died April 30, 1956, while finishing a speech at Washington and Lee University in Virginia. His last words were, "I would rather be a servant in the house of the Lord than to sit in the seats of the mighty."

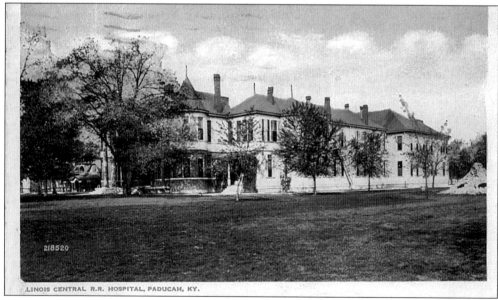

218520

ILINOIS CENTRAL R.R. HOSPITAL, PADUCAH, KY.

ILLINOIS CENTRAL RAILROAD HOSPITAL, PADUCAH. For many years, the ICRR owned and operated its own hospital along Broadway in Paducah to treat railroad employees. The original building was constructed in the mid-1890s. This structure burned on July 10, 1917 and was replaced by the building seen here. In 1957, the hospital closed and the building was converted to an office building known as the Katterjohn Building.

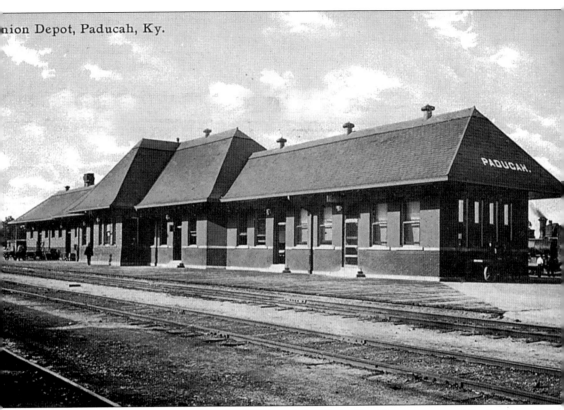

UNION STATION, PADUCAH. In 1900, the ICRR and the Nashville, Chattanooga, and St. Louis Railway (NC&StL) teamed up to build Union Station. Located in the "Littleville" community (just off the present-day Irvin Cobb drive and its intersection with Brown Street), the depot replaced two older depots in the crowded downtown district. In 1917, the Chicago, Burlington, and Quincy Railroad (CB&Q) also began using the station when that railroad began serving Paducah. The CB&Q dropped its passenger service in 1939, and then on March 13, 1951, the NC&StL ended passenger service to Paducah. Finally, on January 29, 1957, the ICRR ended its passenger service in Paducah and for the first time in over 100 years. Paducah was no longer served by passenger trains. After sitting empty for several years, the depot was demolished in September 1964. The concrete platform is still in place and is used by a company to unload railroad cars loaded with ties.

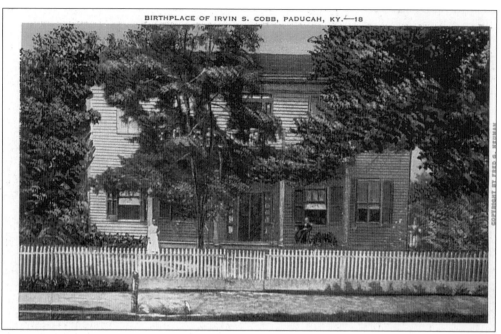

IRVIN S. COBB BIRTHPLACE, PADUCAH. Next to Alben Barkley, Paducah's most famous native is Irvin S. Cobb. While working as a reporter for the Paducah papers in the 1890s, Cobb recorded numerous amusing and interesting anecdotes that he later turned into novels and short stories. In 1911, Cobb began writing for the *Saturday Evening Post* and even did some acting.

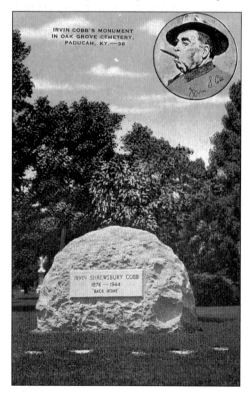

IRVIN S. COBB GRAVE, PADUCAH. Born on June 23, 1876 in his grandfather's house on South Third Street (this house was demolished in 1914), Cobb died on March 10, 1944, in New York City. His cremated remains were buried in Oak Grove Cemetery under a large boulder with the epitaph "Back Home."

CHIEF PADUKE STATUE. When first settled, Paducah was originally called "Pekin." In 1829, William Clark changed the name of the town to Paducah, in honor of Chief Paduke, a local Chickasaw chief. This statue of Chief Paduke was created in 1909 by Lorado Taft. Originally located in front of the old Paducah Courthouse at Fifth and Broadway, it is now sits along Jefferson Street.

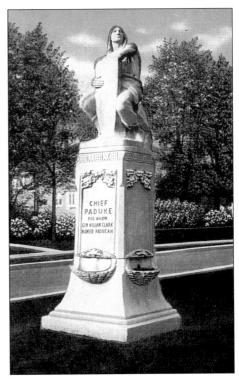

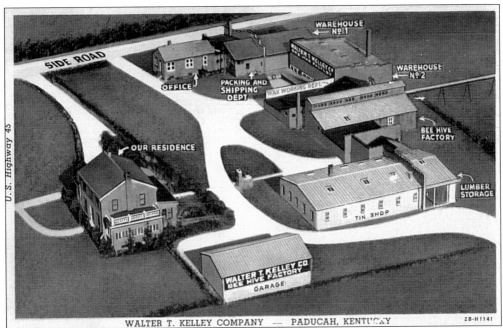

WALTER T. KELLEY CO., PADUCAH. The Walter T. Kelley Co. billed itself as the "Only Complete Bee Hive Factory South of the Ohio River." This card illustrates the company's factory along US45, which was located behind the owner's residence. The factory consisted of a tin shop, wax working department, woodworking shop, two warehouses, a shipping department, and an office.

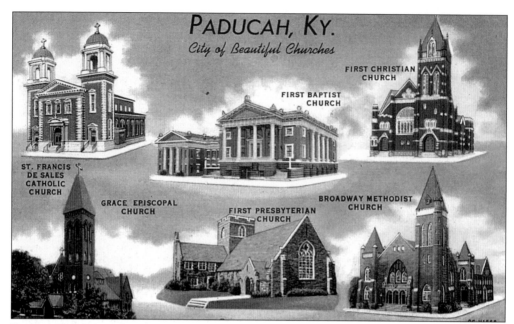

PADUCAH, CITY OF BEAUTIFUL CHURCHES. Over the years, many elegant churches have been constructed in Paducah. Although several large churches have been constructed on the outskirts of town in recent years, most of the downtown churches still have vibrant congregations and a couple have even expanded their buildings recently.

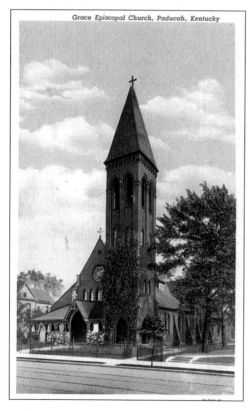

GRACE EPISCOPAL CHURCH, PADUCAH. Located along Broadway, Grace Episcopal Church was established in 1846. Its first building was used as a hospital during the Civil War by Union troops. During this time, the pews sat outside, where they were gnawed and kicked by the troops' mules. The present building was constructed in 1873–1874 and is believed to be the oldest surviving church building in Paducah.

BROADWAY METHODIST CHURCH, PADUCAH. Founded around 1832, Broadway United Methodist Church constructed its first building in 1841 at the intersection of Broadway and Fourth Streets. The church moved to its present location at Broadway and Seventh Streets in 1896, and was rebuilt in 1929–1930 after a fire. United States Vice-President Alben W. Barkley was a member and after his death, his funeral service was held at Broadway Methodist.

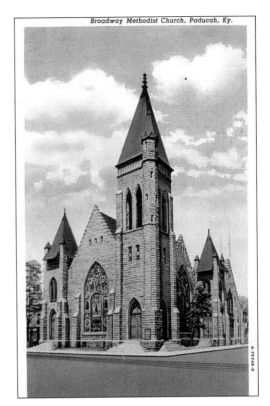
Broadway Methodist Church, Paducah, Ky.

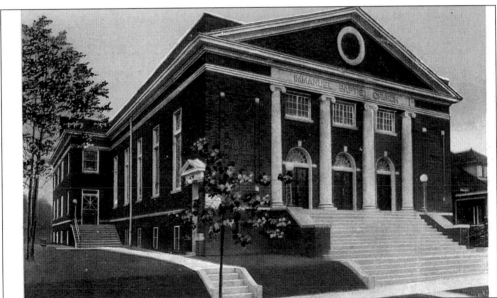

IMMANUEL BAPTIST CHURCH, PADUCAH. In early 1918, members of Paducah's Second Baptist Church began planning for a new building along Murrell Boulevard. Previously, the church had been located at the corner of Ninth and Ohio Streets. When the building seen here was finished in February 1922, the church changed its name to Immanuel Baptist Church. In 1959, the church moved to its existing building on Buckner Lane.

St. John's Catholic Church, near Paducah, Ky.

ST. JOHN'S CATHOLIC CHURCH, PADUCAH. Established around 1840, St. John's originally met in a log cabin that was also used as a post office. After that building burned, it was replaced in 1869 by a wooden frame building. The present building was built in 1932 and has been expanded to accommodate a school.

PASCHAL STUDIO, PADUCAH. Thanks to home computers and full-color printers, today it is quick and easy to take a family photo and produce a wide variety of cards and letters. But in the early 1900s, this process could be done only by a professional studio, usually at considerable expense. This postcard featuring a young lady and presumably her younger brother was produced by the now defunct Paschal Studio. Unfortunately, their names are unknown.

LAKE VIEW COUNTRY CLUB, PADUCAH. In September 1926, the Lake View Country Club was built south of Paducah off Lone Oak Road. Approximately $150,000 was spent to construct the clubhouse, a golf course, and a pool. Later, its name was changed to Rolling Hills Country Club and it is still in existence.

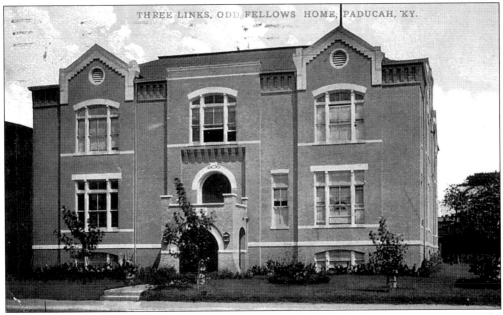

THREE LINKS, ODD FELLOWS HOME, PADUCAH. Better known as the Odd Fellows Society, the International Order of Odd Fellows is one of the oldest fraternal organizations. The first Odd Fellows lodge in Paducah was established in 1845 and eventually at least 14 Odd Fellow lodges were established in Paducah. For many years, the lodges operated this magnificent home.

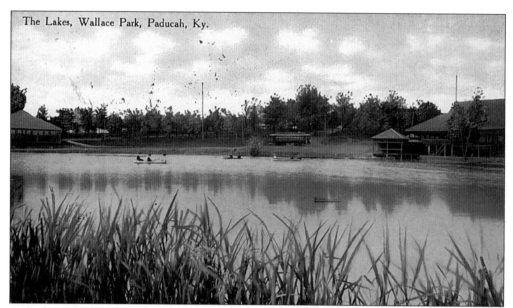

The Lakes, Wallace Park, Paducah, Ky.

WALLACE PARK, PADUCAH. Around 1890, the company that operated Paducah's streetcars developed a large park around Broadway and Thirty-second Street. At that time, this area was just outside Paducah's city limits. Originally named LaBelle Park, the park included a lake, dance pavilion, casino, and even a zoo with exotic animals. The park was renamed Wallace Park around 1904 and died in the late 1920s along with the streetcars.

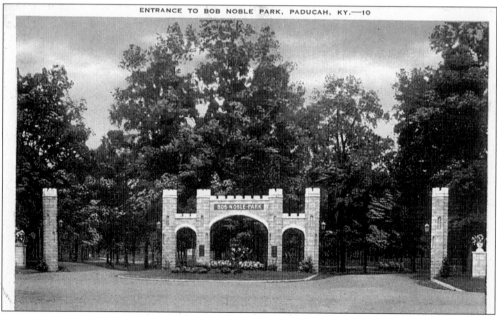

ENTRANCE TO BOB NOBLE PARK, PADUCAH, KY.—10

NOBLE PARK ENTRANCE, PADUCAH. As a replacement for the privately owned Wallace Park, the city of Paducah purchased 114 acres at the intersection of Park Avenue and Twenty-eighth Street. Initially named Forest Park, it saw very little development until Paducah native Robert Noble donated $10,000 towards construction costs if the city matched the funds. The city accepted the offer and the park was renamed Noble Park.

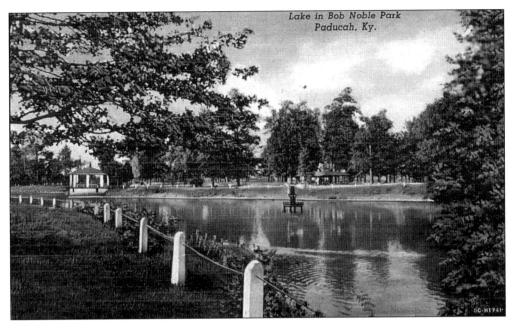

LAKE IN NOBLE PARK, PADUCAH. One of the more popular features of Noble Park is the lake. In the center of the lake is a small house for the ducks that live there and eagerly accept food from park visitors. During the Christmas season, the entire park is decorated with an elaborate light display that attracts spectators from throughout western Kentucky and southern Illinois.

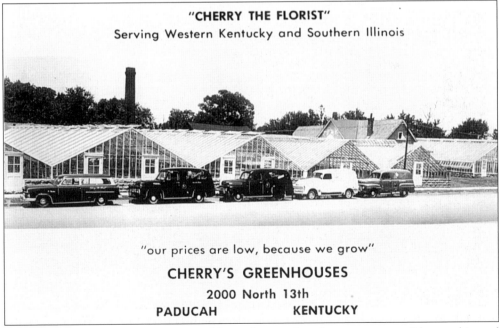

CHERRY'S GREENHOUSES, PADUCAH. "Our prices are low, because we grow" boasts this card for Cherry's Greenhouses. Delivery vehicles are seen lined up in front of the company's greenhouses, where a wide variety of plants and flowers were grown. Today the company operates from Broadway.

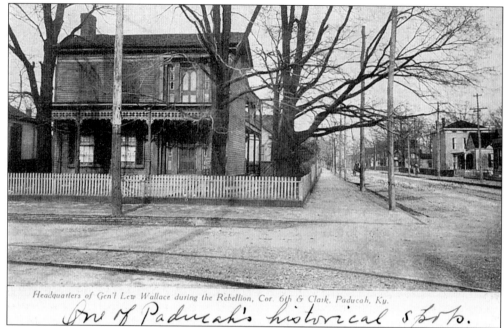

Headquarters of Gen'l Lew Wallace during the Rebellion, Cor. 6th & Clark, Paducah, Ky.

One of Paducah's historical spots.

GEN. LEW WALLACE HEADQUARTERS, PADUCAH. On September 6, 1861, Paducah was occupied by United States Army troops under the command of Ulysses S. Grant. Most officers and troops were quartered at Fort Anderson, which was built near downtown. However, Gen. Lew Wallace briefly used this residence at the corner of Sixth and Clark Streets as his headquarters. Note the streetcar tracks running down both streets.

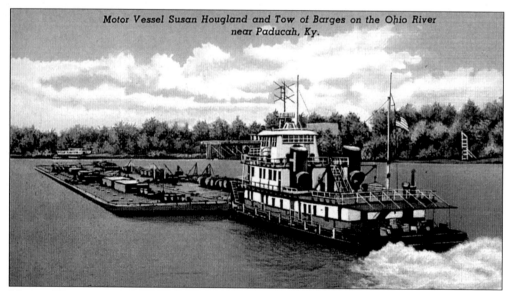

Motor Vessel Susan Hougland and Tow of Barges on the Ohio River near Paducah, Ky.

MOTOR VESSEL *SUSAN HOUGHLAND* ON OHIO RIVER, PADUCAH. In this view, the towboat Susan Houghland is seen pushing six barges loaded with 120,000 barrels of petroleum products on the Ohio River past Paducah. There are several facilities in and around Paducah engaged in the business of loading or unloading these giant barges. Coal, grain, and gasoline are some of the commodities handled by barges.

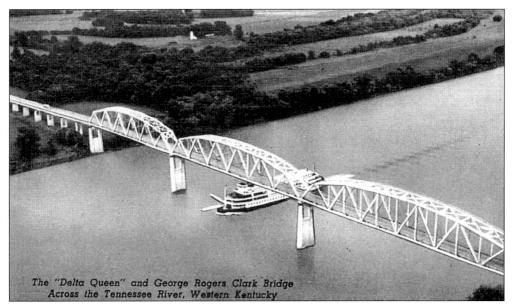

The "Delta Queen" and George Rogers Clark Bridge Across the Tennessee River, Western Kentucky

GEORGE ROGERS CLARK BRIDGE. Paducah sits on land given to George Rogers Clark as a reward for his Revolutionary War service. The land remained mostly undeveloped until Clark died in 1818 and the land passed to his younger brother, William Clark, who explored the Pacific Northwest with Meriwether Lewis. The elder Clark is commemorated by the US60 Bridge over the Tennessee River just east of Paducah.

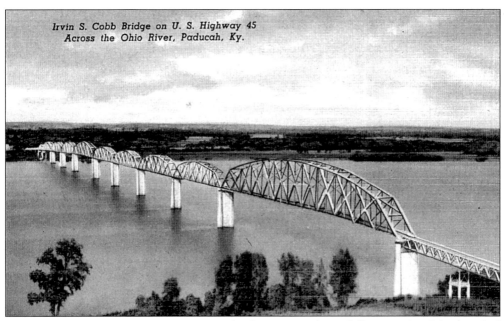

Irvin S. Cobb Bridge on U. S. Highway 45 Across the Ohio River, Paducah, Ky.

IRVIN S. COBB BRIDGE, PADUCAH. By the late 1920s, three different railroad bridges had been built across the Ohio River in western Kentucky, but there were no highway bridges. That changed on May 8, 1929, when the Irvin S. Cobb Bridge opened between Paducah and Brookport, Illinois. The bridge took about a year and a half to construct and cost approximately $1.2 million. It is still in use today.

"BIDE-A-WEE," PADUCAH. Better known as Whitehaven, this is undoubtedly the most famous house in all of western Kentucky. Built in the 1860s by Edward Anderson along Lone Oak Road, the main highway connecting Paducah to Mayfield and Fulton, the house was sold in 1903 for $4,000 to Edward Atkins. During remodeling, a large portico and six massive columns were added to the front, transforming an ordinary farmhouse into an elegant mansion. The house was sold in 1907 to Paducah mayor James P. Smith and renamed "Bide-a-wee." Over the years, numerous social gatherings were held at the house, but in 1968 the last Smith family members moved out of the house and it began to quickly deteriorate. Thanks to its prominent location at the intersection of Lone Oak Road and the soon-to-be-built Interstate 24, the house's plight attracted the attention of community preservationists. In 1981, the state of Kentucky bought the house, completely restored it, and in 1983, opened the house as a rest stop for travelers. The house was renamed "Whitehaven," reviving an early name.

Seven
CAIRO, ILLINOIS *and*
CLINTON, COLUMBUS,
HICKMAN, FULTON

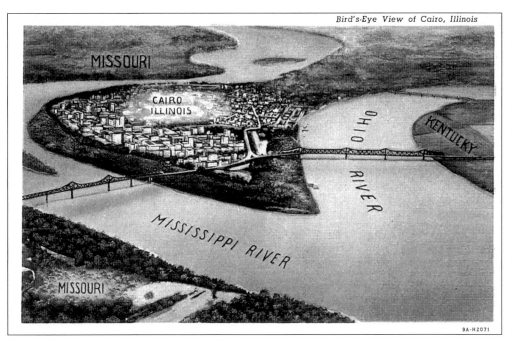

BIRD'S-EYE VIEW OF CAIRO, ILLINOIS. The author chose to include five postcards from Cairo, Illinois, because of the city's historical influence on life in western Kentucky. This postcard illustrates how the city is jammed into the very southern tip of Illinois and is surrounded by the Ohio and Mississippi Rivers. However, the card vastly overstates the size, quantity, and location of the city's buildings.

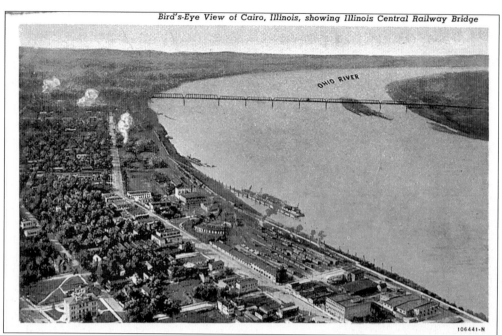

BIRD'S-EYE VIEW OF CAIRO, ILLINOIS. This view shows the bustling city that Cairo used to be. Several railroad yards, boat wharfs, and ferry landings were located downtown but Cairo's prominence as a river town declined in the late 1800s with the growth of the railroads. In turn, the railroads lost their prominence in the mid-1900s with the growth of highways.

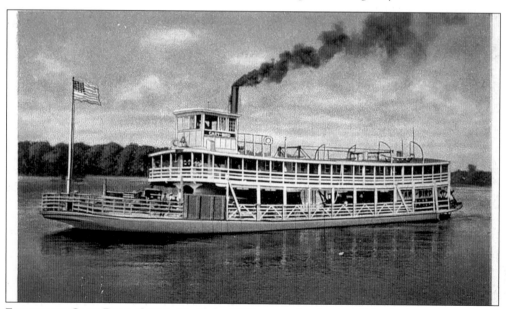

FERRYBOAT CARY BIRD, CAIRO. Until the 1930s, motorists leaving Cairo had to rely on ferries to cross the Ohio River into Kentucky or the Mississippi River into Missouri. One of the last ferries in service is seen here. Captains of these steam-powered paddle wheelers had to be skilled, since both rivers tended to flood in the spring but often became very shallow during the dry summer months.

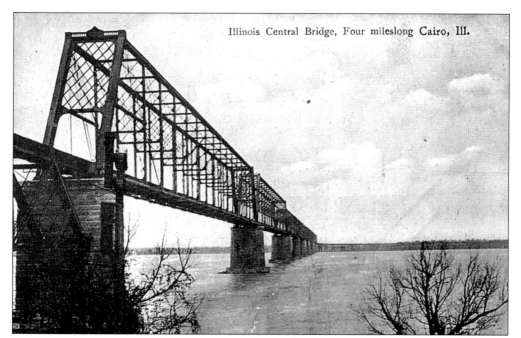

Illinois Central Bridge, Four mileslong **Cairo, Ill.**

ILLINOIS CENTRAL RR BRIDGE, CAIRO, ILLINOIS. Working south from Centralia, the ICRR reached Cairo in 1854. Then in the 1870s, the ICRR built a line from Wickliffe, Kentucky, (just across the river from Cairo) south to Jackson, Tennessee. River ferries connected these two lines until October 29, 1889, when ICRR opened a bridge across the Ohio River. This view is from Cairo looking towards Kentucky.

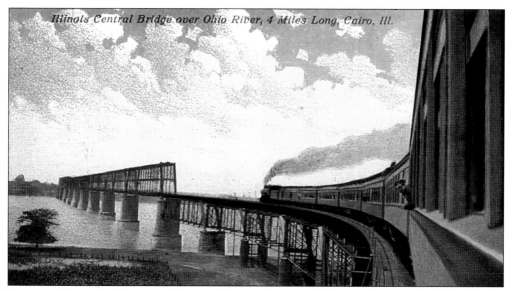

Illinois Central Bridge over Ohio River, 4 Miles Long, Cairo, Ill.

ILLINOIS CENTRAL RAILROAD BRIDGE, CAIRO, ILLINOIS. Many early postcards claim that the Cairo Bridge is four miles long. The spans over the river total approximately 2,600 feet long, while the steel trestle on the Kentucky side leading up the bridge is about 3.5 miles long. Regardless, the bridge was an amazing accomplishment and cost nearly $3 million. It has since been completely rebuilt.

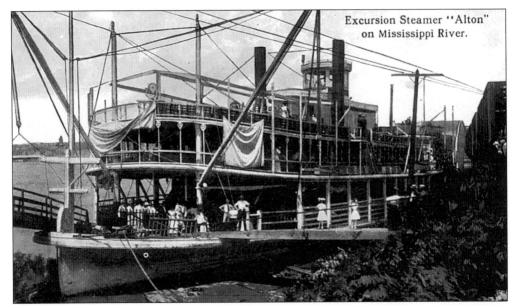

Excursion Steamer "Alton"
on Mississippi River.

EXCURSION STEAMER *ALTON* ON MISSISSIPPI RIVER. From the mid-1800s to the early 1900s, excursion boats such as the *Alton* routinely stopped at western Kentucky towns along the Mississippi and Ohio Rivers. These boats provided an enjoyable and inexpensive way to see the scenery along the river. A handful of boats such as the *Delta Queen* and *Mississippi Queen* still ply the river offering luxury overnight trips.

"COMING HOME BY RAIL." That is the caption of this postcard showing a hobo walking down the tracks. The railroads in western Kentucky offered direct connections to much of the central United States but riding the rails was often dangerous and even deadly. Many hobos were hardened criminals who did not hesitate to rob or assault their fellow riders. There was also a constant threat of train derailments.

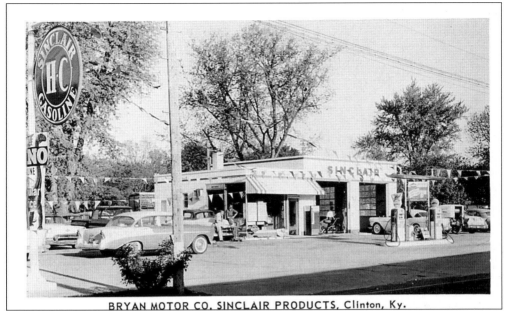

BRYAN MOTOR CO., CLINTON. The caption on the back of this card reads "Gas - Oil - Grease - Wash - Polish - Tires - Batteries - Road Service - Good Used Cars - We appreciate your business and offer special service to tourists." This type of full-service station is all but extinct today thanks to convenience stores and shops that offer quick oil changes.

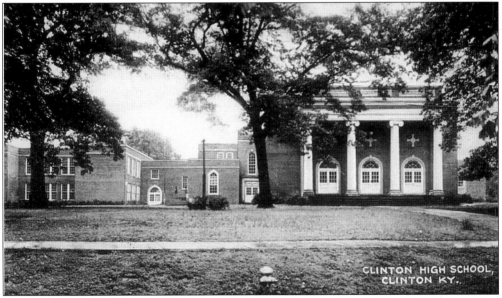

CLINTON HIGH SCHOOL, CLINTON. The first public high school in Kentucky west of the Tennessee River is believed to have been established in Clinton. From 1917 to 1937, the public high school was housed in a building formerly occupied by the Clinton College, a private school operating between 1874 and 1913. Then, in 1937, that building was demolished and replaced by the building seen here. The white columns on this building were salvaged from the old Clinton College building.

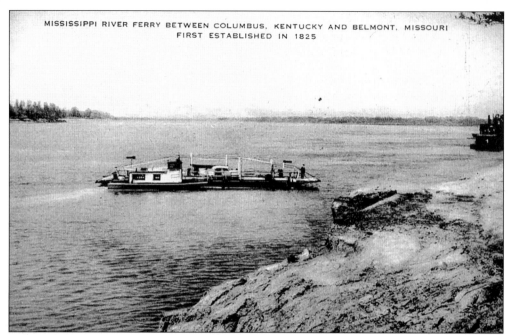

MISSISSIPPI RIVER FERRY BETWEEN COLUMBUS, KENTUCKY, AND BELMONT, MISSOURI. For the early settlers heading westward, the Mississippi River was a major obstacle. In 1825, a ferry was established between Columbus, Kentucky, and Belmont, Missouri. In time, the primitive paddle wheelers were replaced by more advanced boats. The Columbus Ferry no longer operates, but a ferry still operates further to the south between Hickman, Kentucky, and Dorena, Missouri.

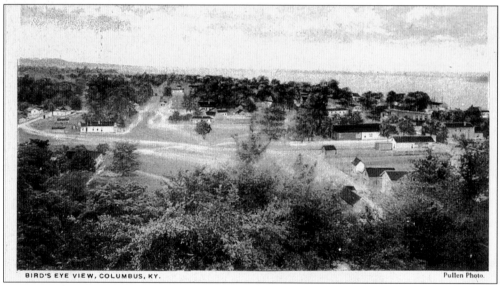

BIRD'S EYE VIEW, COLUMBUS, KY.　　　　　　　　　　　　　　　Pullen Photo.

BIRD'S-EYE VIEW, COLUMBUS. The Mississippi River has helped create and destroy several towns in western Kentucky. Seen here is Columbus before the devastating floods in early 1927 that destroyed most of the town. After the floods, the Red Cross paid to relocate 39 buildings to the bluffs overlooking the river. The old town site was then abandoned and a new Columbus sprang up atop the bluffs.

CONFEDERATE ANCHOR AND CHAIN, COLUMBUS-BELMONT STATE PARK. Between September 1861 and January 1862, the bluffs overlooking Columbus were occupied by Confederate troops. In an attempt to block Union gunboats from using the Mississippi River, a giant chain was strung across the river. Today the battleground is a state park and a key artifact is one of the seven-ton anchors used to secure the massive chain strung across the river.

Confederate Anchor and Chain at Columbus-Belmont State Park Columbus, Ky.

BLUFFS OVERLOOKING MISSISSIPPI RIVER, COLUMBUS. Another of Maurice Metzger's postcards (see pages 27, 49, and 53) shows the tall bluffs occupied by Confederate troops in late 1861 and early 1862. The Confederate fort, called Fort DeRussey, was known as the "Gibraltar of the West" due to its location and impregnable fortifications.

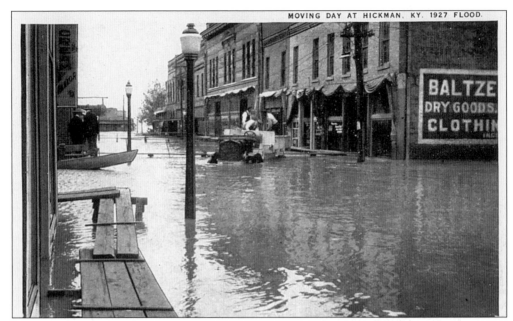

MOVING DAY DURING 1927 FLOOD, HICKMAN. Located along the Mississippi River, Hickman has been hit with several floods over the years. In this scene, several men are loading a truck with items salvaged from one of the downtown stores. Take note of the temporary wooden "sidewalks" built to allow a person to walk around town without getting wet.

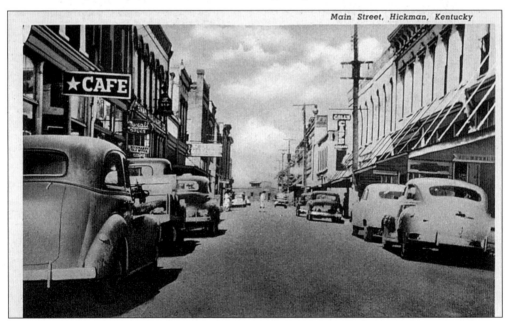

Main Street, Hickman, Kentucky

MAIN STREET, HICKMAN. Rather than relocating their town, as residents in Columbus did after the 1927 flood, the city of Hickman decided to stay put and instead build a floodwall along the river. This view from the late 1950s or early 1960s shows a bustling downtown district. In recent decades, the population of many towns along the Mississippi River has slowly fallen but Hickman's has remained steady.

Fulton County Courthouse. Hickman, Kentucky

FULTON COUNTY COURTHOUSE, HICKMAN. Not all of Hickman is located directly alongside the river. Part of the town, including the courthouse, sits high-and-dry on a bluff overlooking the river. Formed in 1845, Fulton County is the 99th of Kentucky's 120 counties to be formed. The present courthouse was built in 1903 and cost approximately $21,000.

JOHN LUTHER "CASEY" JONES. This card features a painting of John Luther "Casey" Jones, undoubtedly the most famous railroad engineer of all time. Born in southeast Missouri in March 1863 (historians debate the exact date and location), Jones moved with his family at an early age to Cayce, Kentucky, midway between Hickman and Fulton. Jones's railroad career began at age 15 when he was hired as a telegrapher's apprentice by the Mobile and Ohio Railroad (M&O), which passed through Cayce. He held several jobs with the M&O, eventually picking up the nickname "Casey." In March 1888, Jones began working for the ICRR as a locomotive fireman and later as engineer. Shortly after midnight on April 30, 1900, passenger train 1, the southbound New Orleans Special, departed Memphis with Jones at throttle. By that time, Jones had already been on duty for over 11 hours. At Vaughan, Mississippi, Jones died when his train rear-ended a freight train. Within a few years, several ballads were written about how Jones ordered his fireman to jump while he rode to his death. This particular card was autographed personally in 1968 by Jones's son, Charles B. Jones Sr.

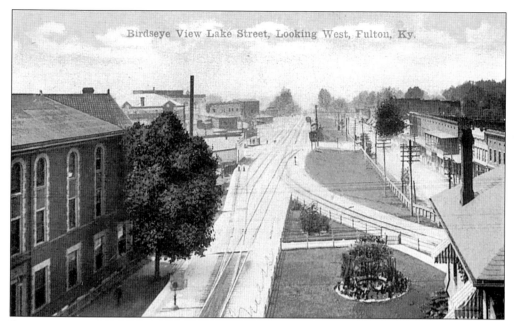

BIRD'S-EYE VIEW OF LAKE STREET, FULTON. First settled in the early 1800s on the Kentucky-Tennessee border, Fulton remained a sleepy town until a predecessor of the ICRR entered town around 1855. Additional railroad lines followed and the town grew rapidly, eventually becoming the twin towns of Fulton, Kentucky, and South Fulton, Tennessee. The roof of the ICRR's offices is visible at far right.

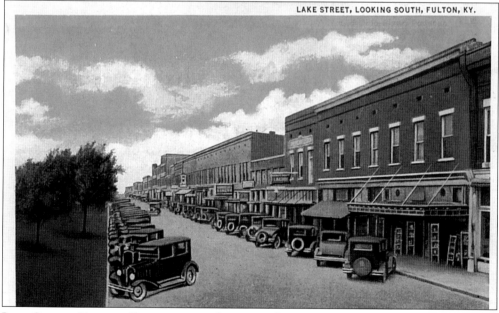

LAKE STREET, FULTON. For many years, the center of commerce in Fulton has been the long row of stores along Lake Street. This card is looking in the same direction as the card above, with the railroad tracks out of view to the left. Numerous trains still pass through Fulton daily but the tracks in the downtown area have been removed.

SMITH CAFE "HOME OF SIZZLING STEAKS"
FULTON, KENTUCKY, ON U. S. HIGHWAYS 45, 51 AND 94

SMITH CAFÉ, FULTON. For many years, one of the most popular dining establishments in Fulton was the Smith Café, located at the intersection of highways KY94, US45, and US51. The café' billed itself as the "Home of Sizzling Steaks." This card was mailed in June 1947, from Fulton, and the handwritten message says the weather was "hot as the dickens," which is very typical for western Kentucky in the summer.

Smith's Cafe
Fulton, Kentucky
On U. S. Highways 45 - 51 and 94

SMITH'S CAFÉ, FULTON. In 1950, the Smith Café was "completely remodeled and air-conditioned" and changed its name slightly to Smith's Café. Contrast this card showing the café after the remodeling to the one at the top of the page, which shows the café before remodeling. The back of the card says the restaurant "represents the finest in modern eating establishments being recommended by American Automobile Association."

FIRST CHRISTIAN CHURCH, FULTON. This church was built on land donated by the descendants of Benjamin Franklin Carr, one of Fulton's first settlers. The Carr family donated a right-of-way to the town's first railroad, the New Orleans and Ohio Railroad, and donated land for the construction of the First Christian and First Baptist churches.

SWIFT AND CO. PLANT, FULTON. For many years, the Swift Plant in Fulton offered area residents a variety of foods. The plant also shipped its products across the country in refrigerated boxcars called "reefers." Two cars can be seen at the loading dock at left. In the days before mechanical refrigeration, the ICRR maintained a large ice plant at Fulton to restock the ice chests of the reefers.

CARR INSTITUTE, FULTON. Built in 1884, Carr Institute was the first school building constructed by the Fulton City School District. The school was named for W.T. Carr, who donated the land that the school sits on. The building cost $15,000.

CARR INSTITUTE, FULTON. In 1942, the school building shown at the top of the page was torn down and replaced by the building shown here. The new school cost $165,0000, or eleven times the cost of the original building. In 1948, the school's name was changed to Carr Elementary.

TWO TYPICAL KENTUCKIANS. "Here's to Old Kentucky, where you never have the blues. Where the Captains kill the Colonels and the Colonels kill the booze," reads part of the caption on the back of the card. The portly gentleman is holding a mint julep, which was a popular drink back in plantation days but today is generally consumed only when the Kentucky Derby rolls around.

Two Typical Kentuckians
Personality and Mint Julep
Relics almost extinct—
K28

My Old Kentucky Home.

The sun shines bright,
In the old Kentucky home,
'Tis summer, the darkies are gay,—
The corn top's ripe,
And the meadows are in bloom,
While the birds make music all the day.
The young folks roll
On the little cabin floor,
All merry and happy and bright.
By 'n by hard times comes a'knockin' at the door
Then my Old Kentucky Home,—good night.

Weep no more my lady,—Oh weep no more to-day,—We will sing one song,
For the old Kentucky home For the old Kentucky home,—far away.

© CAUFIELD & SHOOK, LOUISVILLE 7A-H3283

"MY OLD KENTUCKY HOME." The official state song is "My Old Kentucky Home," composed by Stephen Foster in the summer of 1852. In today's stress-filled, always-on-the-go world, the song's lyrics providing a refreshing reminder of how life used to be in the Bluegrass State.

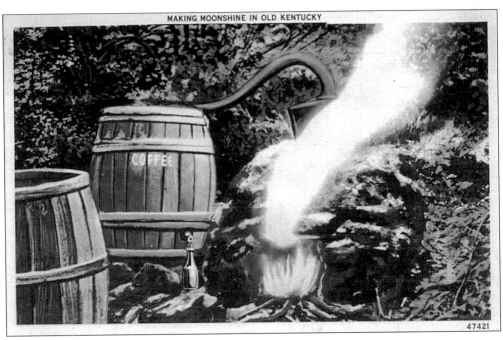

TWO STEREOTYPICAL VIEWS OF KENTUCKY. These two postcards help perpetuate the myth that Kentucky is overrun by race horses, the grass is blue, and that everyone lives in the hills and makes moonshine. But, of course, that's not the case. Yes, there are portions of the state where the grass grows with a bluish tint, but that is mostly in central Kentucky, the same area where most racehorses are raised. Moonshine busts do occasionally occur but are very rare.

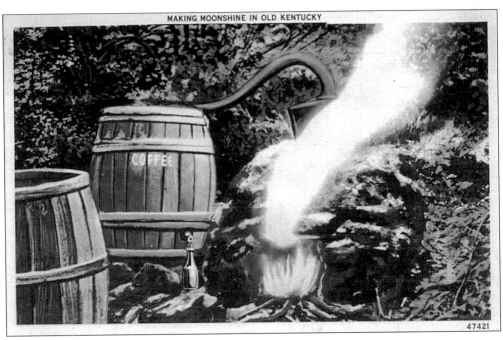

Cypress Trees, Reelfoot Lake, Tenn.

REELFOOT LAKE. Before wrapping up our postcard voyage we will hop across the border and take a quick look at Reelfoot Lake, about 20 miles south of Fulton. This 15,000-acre lake was formed in late 1811 and early 1812 by a series of massive earthquakes that caused the earth to sink. The Mississippi River then flowed into the sunken ground to form Reelfoot Lake.

Lotus Plants, Reelfoot Lake, Tenn.

REELFOOT LAKE. Over the years, Reelfoot Lake has become a very popular attraction for sportsmen and nature lovers alike. The average depth is about five feet, which allows for the growth of cypress trees and a wide variety of aquatic plants. In recent years, the lake has been slowly filling with silt but fortunately, several different measures are being considered to save the lake.

KENTUCKY STATE LINE, FULTON. Heading back into Fulton, we pass by this welcome sign that reads "We hope you have enjoyed your visit." The author also hopes that you have enjoyed this postcard journey through western Kentucky and that the cards revived fond memories.